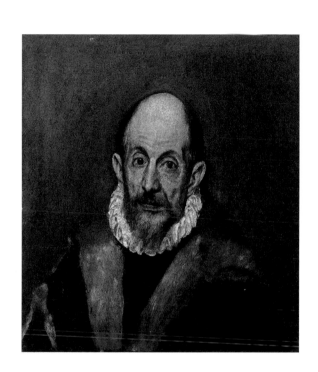

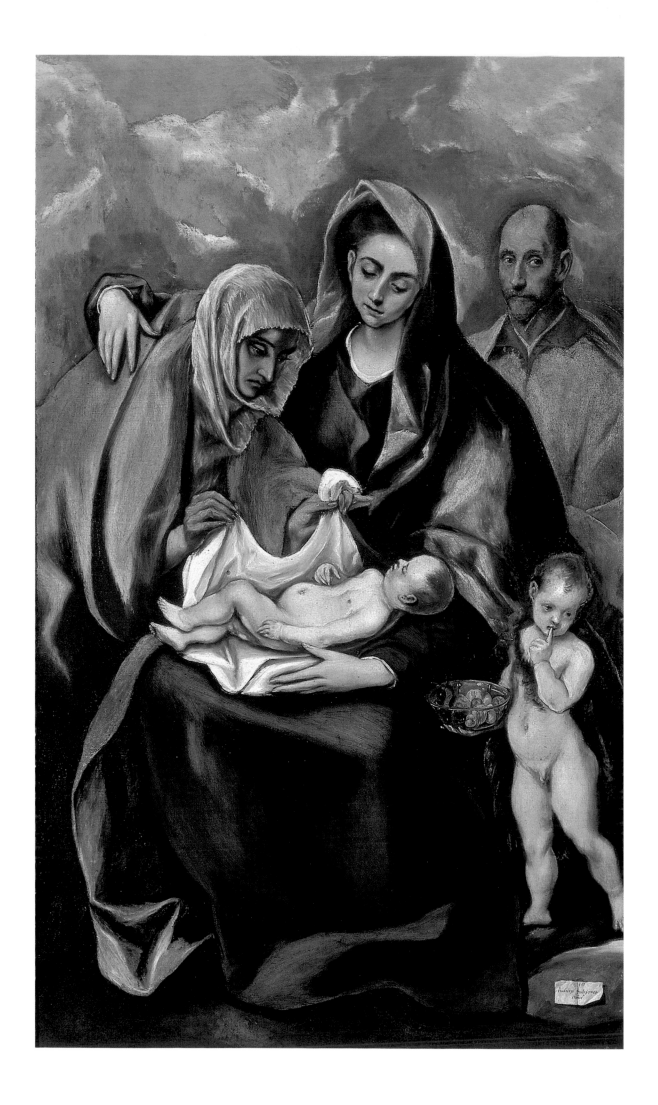

Michael Scholz-Hänsel

EL GRECO

A PROPHET OF MODERNISM

1541–1614

TASCHEN

PAGE 1:
Self-Portrait (?), c. 1590–1600
Oil on canvas, 52.7 x 46.7 cm (20.7 x 18.4 in.)
New York, The Metropolitan Museum of Art

The identification of this painting as a self-portrait is no more than a hypothesis.
It rests on the great expressive power of the depiction, on comparisons with
other presumed self-portraits in El Greco's paintings, as well as on the fact
that a self-portrait was listed in the inventory of Jorge Manuel's estate.

PAGE 2:
The Holy Family with St Anne, mid 1580s
Oil on canvas, 178 x 105 cm (70 x 41.3 in.)
Toledo, Museo de Santa Cruz

To stay informed about upcoming TASCHEN titles, please request our magazine
at www.taschen.com/magazine, find our app for iPad on iTunes,
or write to TASCHEN America, 6671 Sunset Boulevard, Los Angeles, CA 90028, USA;
contact-us@taschen.com; Fax: +1-323-463-4442.
We will be happy to send you a free copy of our magazine,
which is filled with information about all of our books.

© 2014 TASCHEN GmbH
Hohenzollernring 53, D–50672 Köln
www.taschen.com

© for the work of Pablo Picasso: Succession Picasso/VG Bild-Kunst, Bonn 2014

Original edition: © 2004 TASCHEN GmbH
Project management: Juliane Steinbrecher, Cologne
Editing and layout: Christiane Blass, Cologne
Translation: John Gabriel, Worpswede
Cover design: Sense/Net Art Direction, Andy Disl and Birgit Eichwede, Cologne
Production: Martina Ciborowius, Cologne

Printed in China
ISBN 978-3-8365-4984-4

Contents

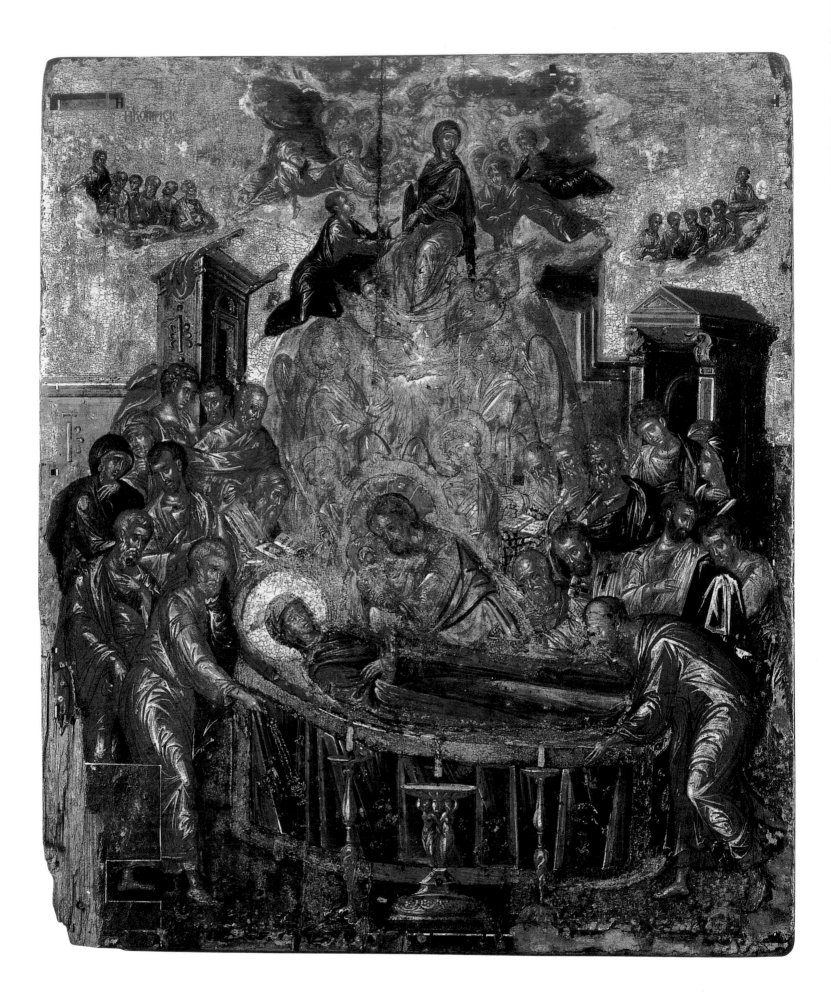

From Icon Painter to "Disciple of Titian"

El Greco is probably the best-known foreign artist of his period, yet we know much less about him than about many lesser Italian artists of the post-Renaissance era. This is due primarily to three reasons: first, the long artistic "pilgrimage" he made through the Mediterranean region before he found a new home in Toledo, Spain, in 1577. Second, the relatively late emergence of art literature in Spain by comparison to Italy. The major Spanish writers on art did not begin publishing until the 17th century. And third and finally, the lack – before Goya – of a Spanish school of engraving, which might have reproduced El Greco's work as prints.

It is indicative in this connection that the Greek painter and sculptor is still known today under his Italian nickname of El Greco, "the Greek", although he spent a mere ten years in Italy by comparison to nearly forty in Spain (in Spanish it would be "El Griego"). He himself continued to sign his paintings until the end of his life in Greek letters with his own name, Domenikos Theotokopoulos, thereby underscoring his origins. In Spain he called himself "Dominico Greco." Only a handful of sources provide information on the Greek artist, a few of which, such as a portrait and a short biography by Francisco Pacheco (1564–1644), teacher and father-in-law of Velázquez, have since been lost. Hence the present monograph is largely based on the numerous small documents which El Greco research has gathered, especially in recent decades. Another important aid has been the artist's own extensive marginal notes, made in two recently rediscovered books from his own library. This, as we know from an inventory of 1614, was that of a learned man of his period.

Domenikos Theotokopoulos was born, probably in 1541, in Candia (now Heraklion), the capital of the island of Crete. This year can be calculated from a statement by the artist of 1606, in which he gives his then age as 65. At that period Crete, like Cyprus, belonged to the Republic of Venice. El Greco's father, Georgios, was a state tax collector and also active as a merchant. The same interests shaped the life of the artist's older brother, Manoussos (1531–1604). About his mother nothing is known, just as we have no information concerning El Greco's first, Greek, wife, and can only speculate about his second wife, a Spaniard.

Although the Venetian merchant Marco Polo (1254–1324) had likely travelled through China as early as 1271 and 1275, and the Genoese Christopher Columbus had in 1492 discovered an ocean passage to America for the Spanish monarchy,

Georgios Klontzas
The Dormition of the Virgin, 1565–1600
Oil on panel, 67 x 79 cm (26.4 x 31.1 in.)
Venice, Istituto Ellenico degli Studi Bizantini e Postbizantini

PAGE 6:
The Dormition of the Virgin, c. 1567
Tempera and gold on panel,
61.4 x 45 cm (24.2 x 17.7 in.)
Ermoupolis (Syros, Greece)
Holy Cathedral of the Dormition of the Virgin

A comparison of El Greco's *Dormition of the Virgin* with a painting on the same subject by his artist-colleague Klontzas reveals several innovations. The most essential are the way Christ turns empathetically towards Mary, who has already ascended to heaven, and the more relaxed pose of her figure.

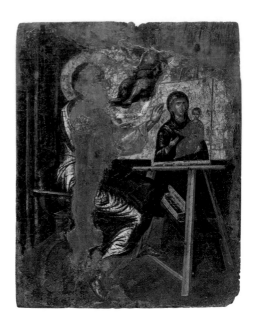

St Luke Painting the Virgin and Child,
c. 1560–1567
Tempera and gold on canvas mounted on panel,
41.6 x 33 cm (16.4 x 13 in.)
Athens, Benaki Museum

Depictions of St Luke as a painter are believed
to date as far back as the end of the phase known
as Iconoclasm (725–842), and were evidently
intended to lend the relevant works of art more
divine authority. In the 15th and 16th century
many artists' guilds and art academies chose
the saint as their patron and named themselves
after him.

in El Greco's time the Mediterranean still formed the geographic hub of the
European world. Three cultures existed here: that of the Latin West, of the Greek
Orthodox East, and that of Islam. Sultan Mohammed II had conquered Con-
stantinople in 1453, yet despite religious barriers a certain exchange continued,
especially in those territories where the cultures overlapped, which was the case
both in Crete and in the later so important Iberian peninsula.

The Republic of Venice was especially interested in the continuation of this
non-belligerent coexistence in the Mediterranean region. Positioned between the
Ottoman Empire to the east and the Hispanic realm to the west, Venice's survival
depended entirely on alliances, since her rise and ongoing power rested solely on
trade relations, which required reliable partners. Down to the time of the early
Renaissance, the inhabitants of the city on the lagoon continued to draw key
cultural stimuli from the Byzantine Empire. After its fall, Venice became the
preferred place of exile for Eastern Orthodox Christians. Yet the exchange was
always reciprocal.

On Crete, in turn, which came under Venetian sway as early as 1211, Western
and Eastern cultures blended. Under the influence of the distant metropolis the
urban centres there, including Candia, gradually took on a Venetian character,
particularly as regards palatial buildings and the design of *piazze*, or city squares
(ill. p. 9). Here, unlike on the mainland, Latin and Orthodox Christianity existed
on a footing of equality, making it impossible to say for certain to which of the
two religions El Greco's family belonged. Art, too, developed on this same basis,
remaining beholden largely to Christian subject matter far into the seventeenth
century, and that not only in El Greco's case. In a special school of icon painting,
now fashionably known as "hybrid", Byzantine ideas combined with Western
influences that came to Crete primarily through prints. The workshops in this
field, which flourished during the late 15th and early 16th century, enjoyed wide
popularity; their products were in demand in the eastern Mediterranean region
and even in Venice.

El Greco must have trained in one of these shops, since as early as 1563 he is
mentioned in a document as a master of icon painting. The three further written
records from Crete that mention El Greco's name date to the year 1566. On 26
December he received permission to sell, at a lottery, a *Passion of Christ*, painted
in the traditional way on a gilded ground. Two days later the value of the picture
was estimated by two artists, one of whom was the well-known Cretan icon
painter Georgios Klontzas (1540–1608) (ill. p. 7). Both Klontzas' involvement
and the relatively high price of 70 ducats would suggest that El Greco had al-
ready achieved a certain reputation by then.

Thanks to the discovery in 1983 of a painting signed with his Greek name
("made by Domenikos Theotokopoulos") in the Holy Cathedral of the Dormi-
tion of the Virgin in Ermoupolis on the island of Syros, we can gain a good idea
of El Greco's artistic skills at that early period. The overall conception of *The
Dormition of the Virgin* (ill. p. 6), dated 1567, reflects a training in icon painting,
whose practitioners took their bearings from stereotyped models rather than
from an observation of nature. The figure depictions in traditional icons are
usually two-dimensional and based on a standard formula, and this is normally
true of their attire as well. The light seems to emanate from inside the forms
themselves, since the intention was to convey a sense of divine illumination.

Original contributions, on the other hand, are the aureole of light radiating
from the dove of the Holy Ghost in the centre of the painting, linking the sleep-
ing Mary with the enthroned Virgin, and the figure of Christ, bending over with

a tender gesture. Another striking iconographic innovation are the three candelabra in the foreground. The middle one with caryatids on its base was likely derived from an engraving. It is probably no coincidence that the signature in Greek letters appears precisely at this point. While the signing of an icon was in itself unusual, the form chosen here was all the more so. According to Lucian, the renowned Greek sculptor Phidias inscribed his works in precisely this way. With this significant detail, in other words, El Greco underscored his considerable ambitions and the humanistic learning which would gain him much attention, especially among scholars.

Another picture which experts generally ascribe to El Greco's period on Crete is *St Luke Painting the Virgin and Child* (ill. p. 8). Painted in egg tempera on wood, the work evinces considerable damage, but luckily the signature has survived ("by Domenikos"). The main motifs, Luke the Evangelist and the portrait of the Virgin as "Hodegetria", based on the model of the Hodegon Church in Constantinople, are still rendered in the traditional, graphic Byzantine technique. But a new approach is also evident in the marginal motifs. These include objects depicted in three dimensions, such as the Renaissance chair and the painter's utensils, as well as the angel soaring down from heaven to reward the artist with a laurel wreath because, as the text on the banderole says, he "has created the divine image".

Joris Hoefnagel
View of Candia and Corfu, c. 1572
From Georg Braun, *Civitates Orbis Terrarum*, 1572–1617, Stapleton Collection

Candia, named after the Arabian El Khandak and now Heraklion, experienced great changes in outward appearance under Venetian rule. Its cultural life, too, was shaped by a mixture of Eastern and Western influences.

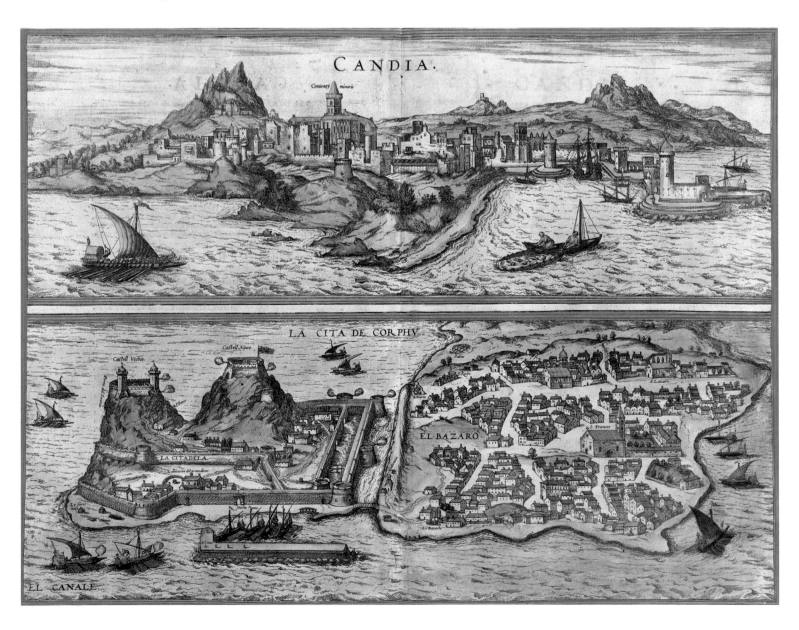

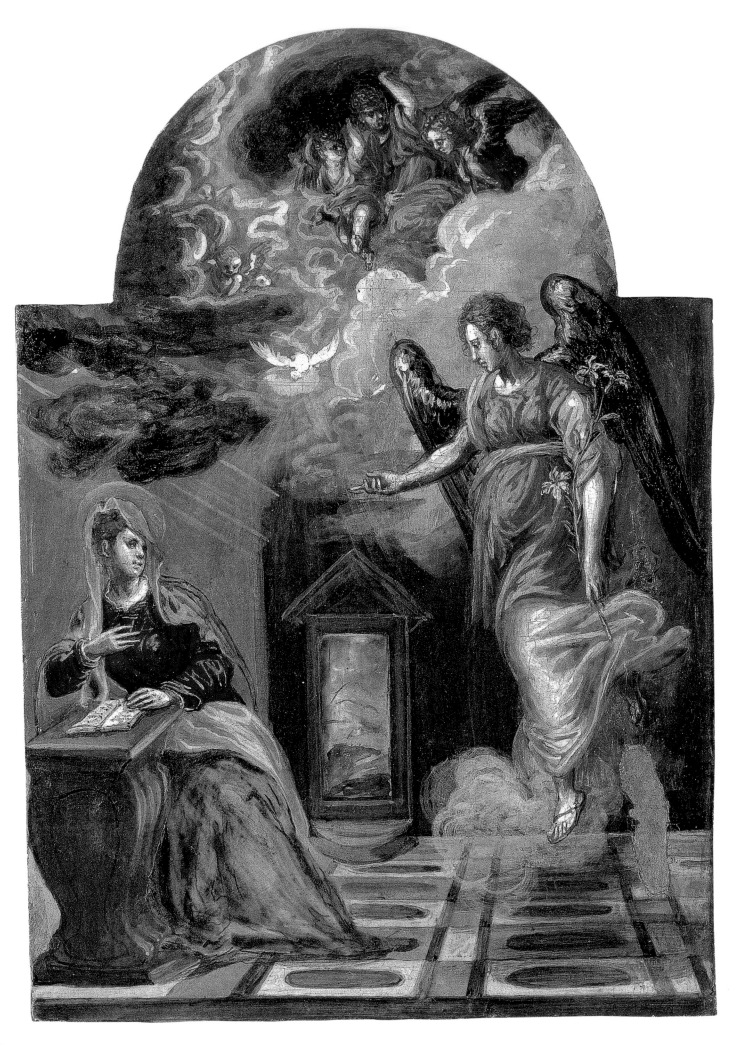

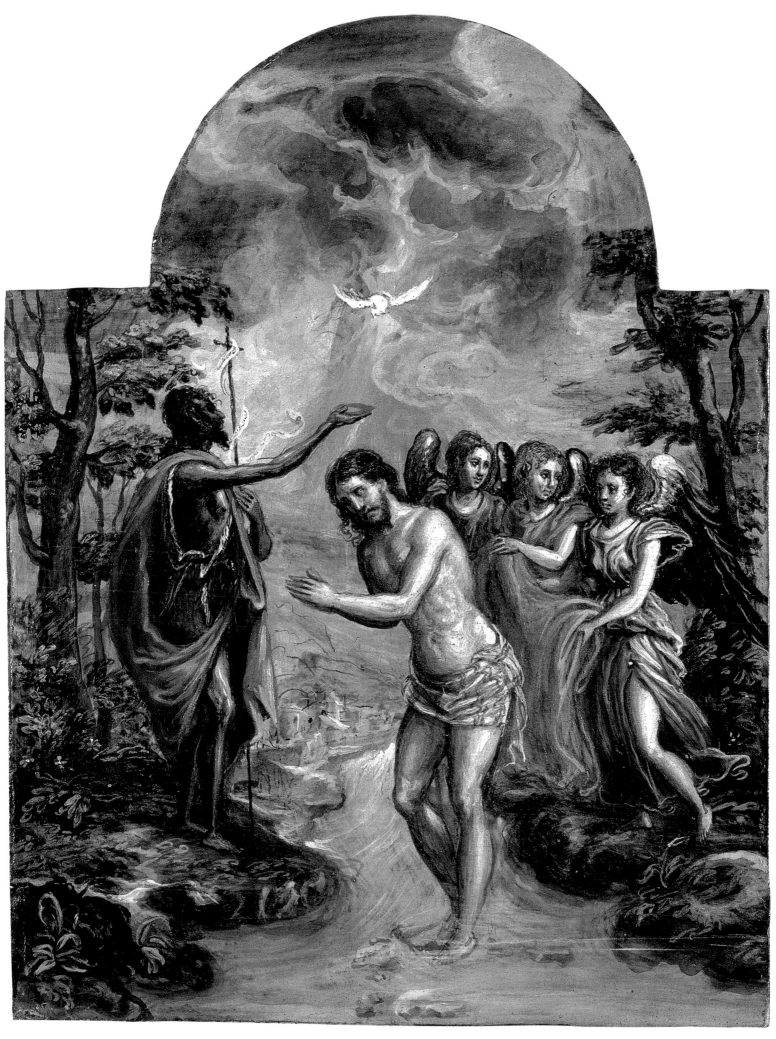

A letter of 18 August 1568 documents El Greco's presence in Venice. It relates that he gave a series of drawings to Manolis Dakypris, to be passed on to the Cretan cartographer Giorgio Sideris, alias Calapodas. Sideris is the first in a long series of figures from the art world – individuals we would today call "intellectuals" – to whom El Greco would largely owe his gradual but continual rise to prominence. Possibly Sideris provided the decisive impulse for El Greco's move to Venice, which recent research dates to as early as spring or summer 1567. The ships preferred to make the voyage, which lasted nearly a month back then, in the favourable weather between May and October.

During his three-year sojourn in Venice, El Greco painted a whole series of works which have one feature in common: evidence of his attempt to adopt the quite different technique of the leading local artists, especially Titian and Jacopo Tintoretto, but also Jacopo Bassano. Now El Greco abandoned the flat, gilded backgrounds of his early works. Instead he strove to place the figures in a perspective space, for whose construction he relied in part on examples set out in architectural tracts such as that by the Venetian Sebastiano Serlio. From the medium of tempera he switched to oils, a technique common in the West since Jan van Eyck. Still, throughout his life he would continue to begin many pictures in tempera. In terms of palette and the handling of light, his most important means of expression, El Greco likewise absorbed crucial influences in the city on the lagoon.

As regards his choice of support, El Greco now began to favour canvas over the wood panels common in the East. In accordance with Venetian practice, he used coarse canvases whose tangible texture augmented the expressive effects he strove for. These were primed with a correspondingly thin layer of white, followed by a pigmented ground in hues ranging from rose to dark red. Finally he drew in the outlines of the figures with black brushstrokes and marked the highlights throughout the picture with white paint and the darkest areas with black and carmine red. Now began the paint application proper, a complex process in which, contrary to first impressions, the artist left nothing to chance. Despite the switch to canvas, he continued to favour relatively small dimensions, which may have been due to an initial lack of orders.

In terms of technique, El Greco would remain a Venetian painter. His craftsmanly skills, combined with an employment of high quality materials, have ensured that the majority of his works have survived in a good state of preservation down to this day.

A work that strikingly illustrates the transition from post-Byzantine icon painter to European artist of the Latin variety is the so-called *Modena Triptych* (ill. p. 13), whose unknown patron perhaps stemmed from a Creto-Venetian family. In its open state, the portable altarpiece shows a total of six scenes: on the front, the central panel bears a rare depiction of the *Coronation of the Christian Knight*, and on the wings we find the *Adoration of the Shepherds* on the left and the *Baptism of Christ* (ill. p. 11) on the right. On the reverse, a *View of Mount Sinai* with its famous convent of St Catherine is flanked by an *Annunciation* (ill. p. 10) and an *Admonition of Adam and Eve by God the Father*. This type of object with its gilded frame elements was common in Cretan workshops of the 16th century, as is its use of wood as a painting support. Quite unusual, on the other hand, are many iconographic elements, such as the female allegories of the three religious Virtues (Faith, Love and Hope) below the coronation of the Christian knight. For these the artist relied once more on prints from the Western Mediterranean area.

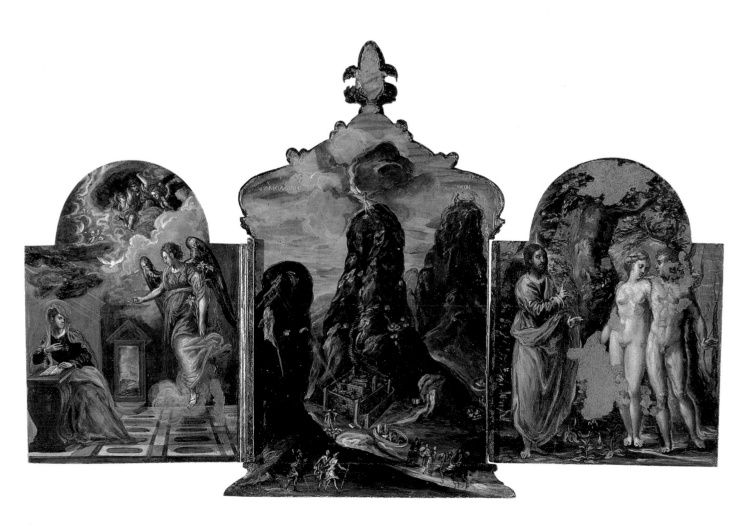

13

Christ Healing the Blind, c. 1565
Oil on panel, 65.5 x 84 cm (25.8 x 33.1 in.)
Dresden, Staatliche Kunstsammlung,
Gemäldegalerie Alte Meister

Like Tintoretto, El Greco relied on an illustration from Sebastiano Serlio's architectectural tract for the view of the city here. That he owned the book is indicated by its listing in an inventory of the artist's library.

15

El Greco's signature on this painting ("by the hand of Domenikos") makes it a key reference work for paintings that evince a similar technique. These include a *Last Supper* (ill. p. 17), now in the Pinacoteca Nazionale in Bologna.

Francisco Pacheco, when he visited El Greco in 1611, was shown a collection of small-format oil reproductions of all the pictures the artist had painted to that point. It is clear that Theotokopoulos regularly referred back to these, producing several works on the same theme and with similar compositions, but done at quite different periods. A particularly good idea of the Greek artist's development can be gained by reference to these series.

An example is *Christ healing the Blind*, whose earliest version, now in the Gemäldegalerie, Dresden, likely dates towards the end of El Greco's sojourn in Venice (ill. p. 14/15). Here two groups of figures are placed in an architectural setting rendered in one-point perspective. On the left we see Christ healing a blind man by touching his eyes, an event commented upon by a group of Pharisees on the right. Inspiration for this painting was taken from two pictures by Tintoretto. The arrangement of the groups was derived from him, as were the view into the distance and the dog in the foreground, a motif very popular in Venice. The poses of certain figures might be traced back to various engravings, a medium on which the artist continued to rely frequently during his Italian period.

A later version of *Christ healing the Blind*, now in Parma (ill. p. 16), may possibly already date to El Greco's Roman period. Instead of wood, here El Greco employed canvas as his support. That the painting was executed in the papal city is suggested not only by the introduction of architectural ruins in the background (possibly representing the Baths of Diocletian), but also by figures which allude both to Michelangelo's *Ignudi*, or nudes, in the Sistine Chapel and to ancient Roman sculptures. The male figure clad only in a light cloth, for instance, recalls a famous classical statue, the *Farnese Hercules*.

Christ Healing the Blind, c. 1570–1575
Oil on canvas, 50 x 61 cm (19.7 x 24 in.)
Parma, Galleria Nazionale

In this second version of the subject, the figures are depicted on a considerably larger scale, which lends them a more convincing relationship to the architectural setting.

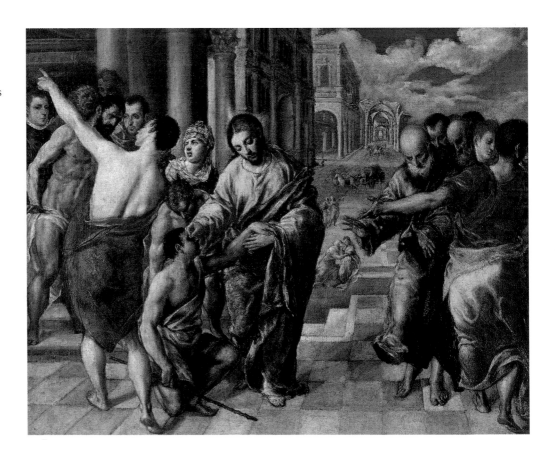

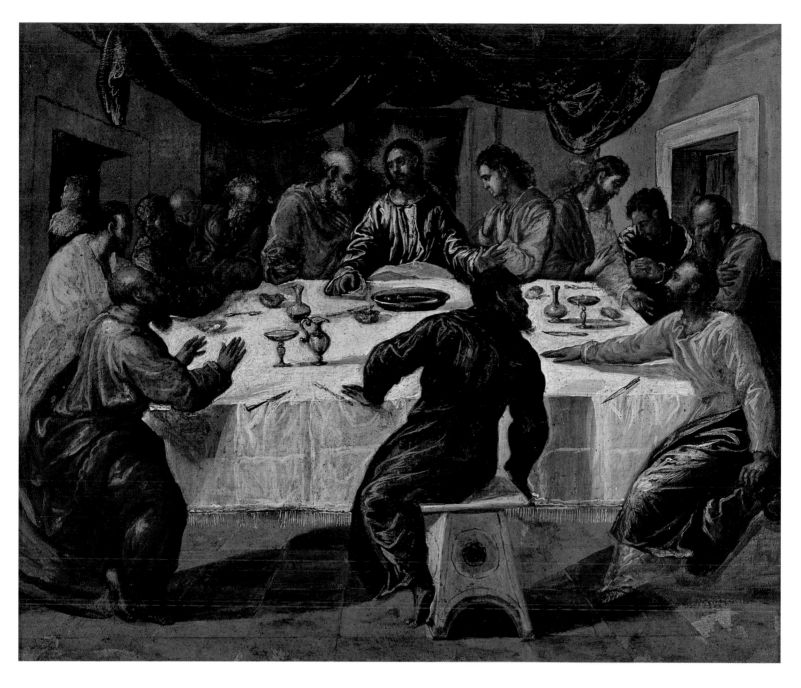

The Last Supper, c. 1568
Oil on wood, 43 x 52 cm (16.9 x 20.5 in.)
Bologna, Pinacoteca Nazionale

The perspective space here is still quite simply structured.
The figures have little corporeal volume and seem more
to hover than actually to sit at the long table.

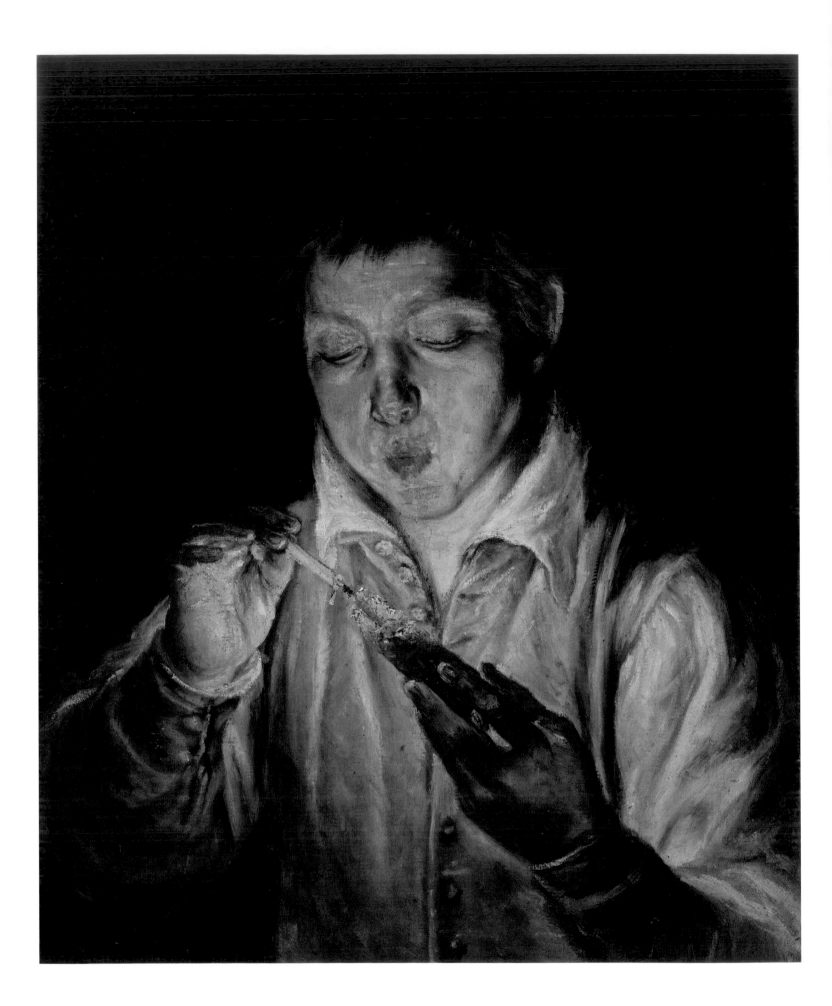

In Search of Work in Rome and Spain

El Greco's presence in Rome in 1570 is evidenced by a letter by Giulio Clovio (1498–1578), a Croatian painter of miniatures, in which Clovio recommends to his patron, Alessandro Farnese, a "giovane Candiotto discepolo di Titiano" ("a young man from Candia, a disciple of Titian"). Adding a reference to a sadly lost self-portrait, which reputedly astonished all the painters in Rome, Clovio asks protection for El Greco and the provision of lodging for him at the Palazzo Farnese.

Perhaps as thanks, El Greco painted a portrait of his friend Clovio, the earliest surviving portrait from the Cretan artist's hand (ill. p. 19). The sitter is depicted holding his most famous work, the Farnese *Book of Hours* which he illustrated for Alessandro Farnese in 1546.

The originality of El Greco's pictorial ideas at this early date is reflected in a subject of which various versions, including copies, exist: *A Boy blowing on an Ember to light a Candle (El soplón)*. One of these works, surviving in the Farnese Collections, may have been directly commissioned by the Duke (ill. p. 18). The subject was very probably a paraphrase of a classical model, but also had several predecessors in Venetian painting. Yet there the depictions tended to be marginal episodes in a larger narrative context, as with Titian or Jacopo Bassano, whose work had a large audience at that period. El Greco's achievement, in other words, consisted in isolating an individual figure and bringing it into close proximity with the viewer by means of the lighting and the low vantage point, known as *sotto in sù*.

Actually there was very little to do for El Greco in the Farnese household, which chiefly required fresco painters. Although the participation of a "pittore Greco" in the decoration of the Villa Farnese at Caprarola is recorded, no painted work can be associated with this written source. At any rate, the artist became acquainted with a further intellectual at the Palazzo Farnese, a man who now became his most significant patron in Rome: the humanist and librarian Fulvio Orsini (1529–1600). The inventory of Orsini's collection would later include seven El Grecos, including his portrait of Clovio.

His lost self-portrait, the portrait of Clovio and the *Boy blowing on an Ember to light a Candle* indicate the direction in which El Greco hoped to find a market niche in Rome: that of portraiture. Perhaps the most outstanding example of his work in this genre is his portrait of *Vincenzo Anastagi* (ill. p. 22). It depicts

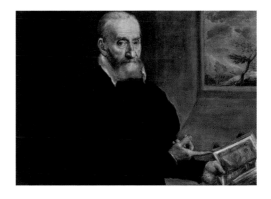

Giulio Clovio, c. 1570
Oil on canvas, 58 x 86 cm (22.8 x 33.9 in.)
Naples, Museo Nazionale di Capodimonte

The half-length portrait of the renowned miniaturist (whom Vasari called "a minor and novel Michelangelo") employs an unusual landscape format. Visible through the window at the right edge is a view of a landscape under a stormy sky.

PAGE 18:
A Boy Blowing on an Ember to Light a Candle (El soplón), early 1570s
Oil on canvas, 60.5 x 50.5 cm (23.8 x 19.9 in.)
Naples, Museo Nazionale di Capodimonte

In his *Historia Naturalis*, Pliny the Elder named several artists who, in painting or sculpture, depicted boys blowing into a fire.

Federico Zuccari
Self-Portrait, after 1588
Florence, The Uffizi

Chains were a favourite gift of princely patrons to their artists. Around 1588 Federico Zuccari proudly depicted himself in a self-portrait wearing just such an honour from Philip II, received for his services in decorating the Escorial.

PAGE 21:
Vincenzo Anastagi, 1571–1576
Oil on canvas, 188 x 126.7 cm (74 x 49.9 in.)
New York, The Frick Collection

The approach of this portrait is so modern that one is tempted to think beyond Velázquez to his 19th-century successor, Edouard Manet.

the sitter clad in cuirass and velvet breeches, his helmet placed on the floor beside him, in an unusually bare room, whose modelling solely by means of the illumination calls to mind Diego Velázquez. In fact, the inventory of Velázquez' estate would later be found to include a full three El Greco portraits.

In the 19th century, even outspoken critics of the artist such as Carl Justi, art historian and pioneer of Spanish art research, always admired his portraits. Still, the painter from Crete strove for recognition in other fields as well. The high demands he placed on his art are reflected in a painting now in the Minneapolis Institute of Arts. *The Purification of the Temple* (ill. p. 22/23), like *Christ healing the Blind*, belongs to one of those series in which El Greco treated the same subject over and over again. It has even been suggested that a few works from the two series were executed as companion pieces – as indicated by similar formats, comparable compositions, and apparently consciously chosen formal oppositions such as the location of the action in an interior or exterior space.

Yet the version in Minneapolis evinces a striking peculiarity which the others do not have. At the lower right edge we see portraits of four men, who represent the leading masters of the High Renaissance. Depicted from left to right are Titian, Michelangelo, Clovio and, presumably, Raphael. As El Greco's own commentaries indicate, he viewed Titian, Michelangelo and Raphael as models to emulate, and the same likely held for his friend and supporter, Clovio. Yet by integrating them in one of his paintings, El Greco not only expressed his gratitude but advanced the claim to be able to rival these masters. But this could not be achieved as long as he restricted himself to a single genre, that of portraiture.

Basically El Greco faced a similar problem in Rome as he had in Venice. He had indeed wanted to settle in one of the great Italian art centres of the 16th century, but in both, potential patrons already had more than a sufficient number of high-ranking artists at their disposal. The competition in Venice and Rome had already put out of the race artists whose starting chances were better than El Greco's. During Titian's lifetime, for instance, his rivals Tintoretto and Paolo Veronese could often obtain a commission only when the master was otherwise occupied. The highly gifted Lorenzo Lotto was even forced to leave Venice due to a lack of patrons, and spent the last two years of his life as a lay brother in Loreto.

When El Greco finally arrived in Rome, Michelangelo had been dead for six years, yet his example continued to be overwhelming and left little room for different approaches. So there was probably an undertone more of despair than of pride in the famous anecdote related by Mancini: El Greco is said to have offered to Pope Pius V to paint over Michelangelo's *Last Judgement* in the Sistine Chapel, renowned but also criticized for its many nudes, with equal mastery but in accord with the new and stricter Catholic thinking. Apparently this offer made him so hated in Rome that he was forced to leave the city.

The only slight chance for a foreign artist like El Greco lay in presenting his own foreignness as a strength and styling himself upon an accepted master who was not present in Rome, Titian, for instance. This was exactly the ploy adopted by Clovio when he recommended El Greco to Cardinal Farnese as a "disciple of Titian."

Yet in the long run El Greco seems to have found little recognition at the Palazzo Farnese. On 6 July 1572 he complained in a letter to the Cardinal that he had been thrown out for no fault of his own. In reaction, El Greco now decided to go his own way. On 18 September he paid the two scudi application fee and joined St Luke's Guild, the painters' association, in Rome, using the name Dominico Greco

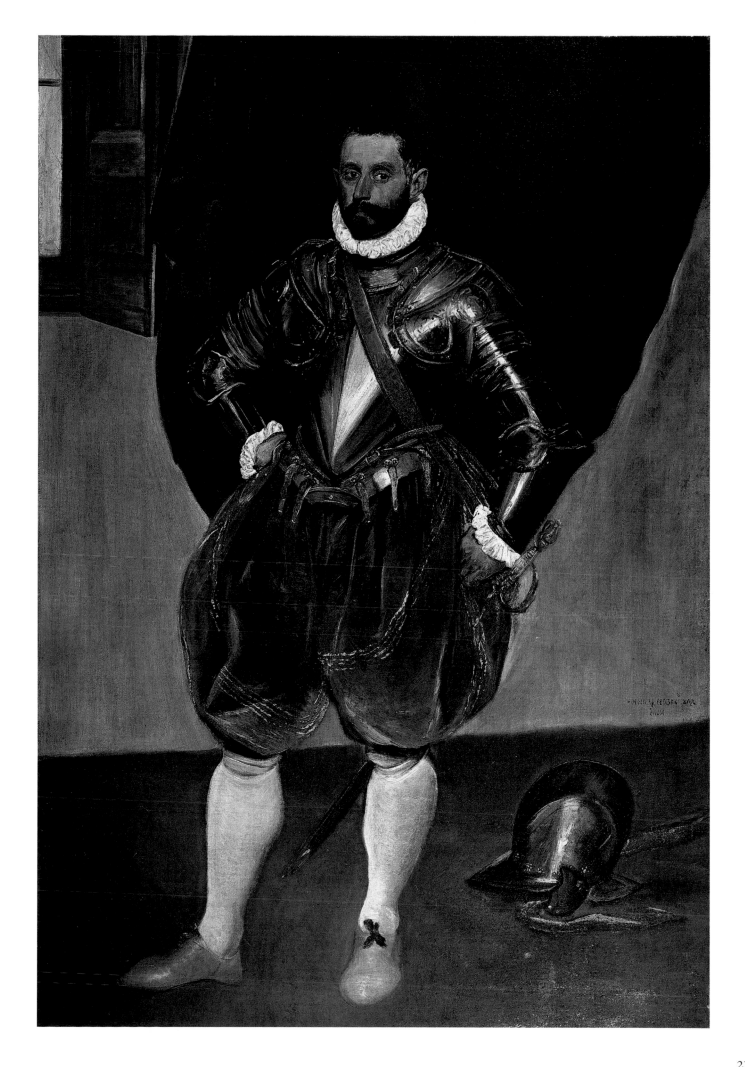

The Purification of the Temple, 1570–1575
Oil on canvas, 116.8 x 149.9 cm (46 x 59 in.)
Minneapolis, The Minneapolis Institute of Arts

El Greco first painted the group of figures representing Titian, Michelangelo, Clovio and Raphael on a separate canvas, which was then mounted on the main painting. This procedure would seem to indicate that the artist intended to make a special statement with this picture.

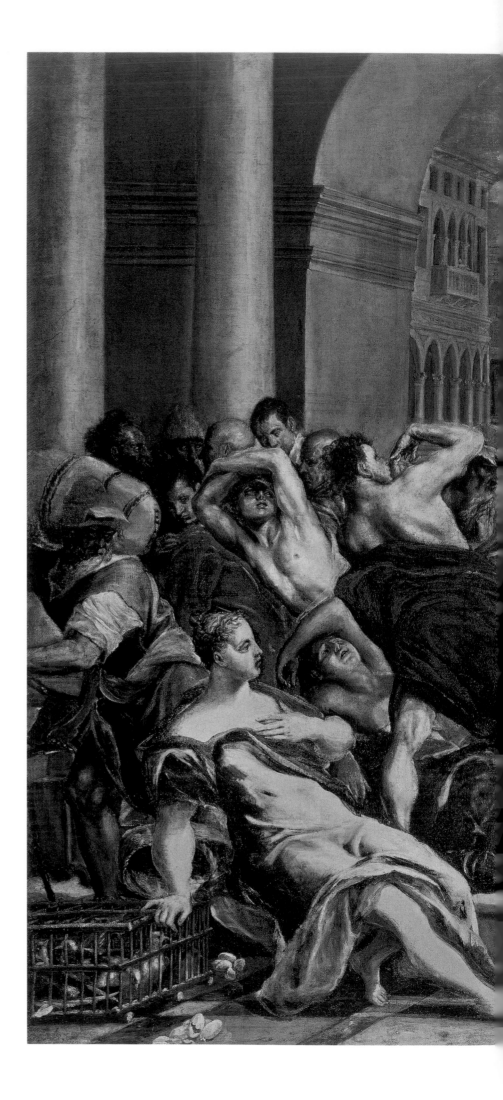

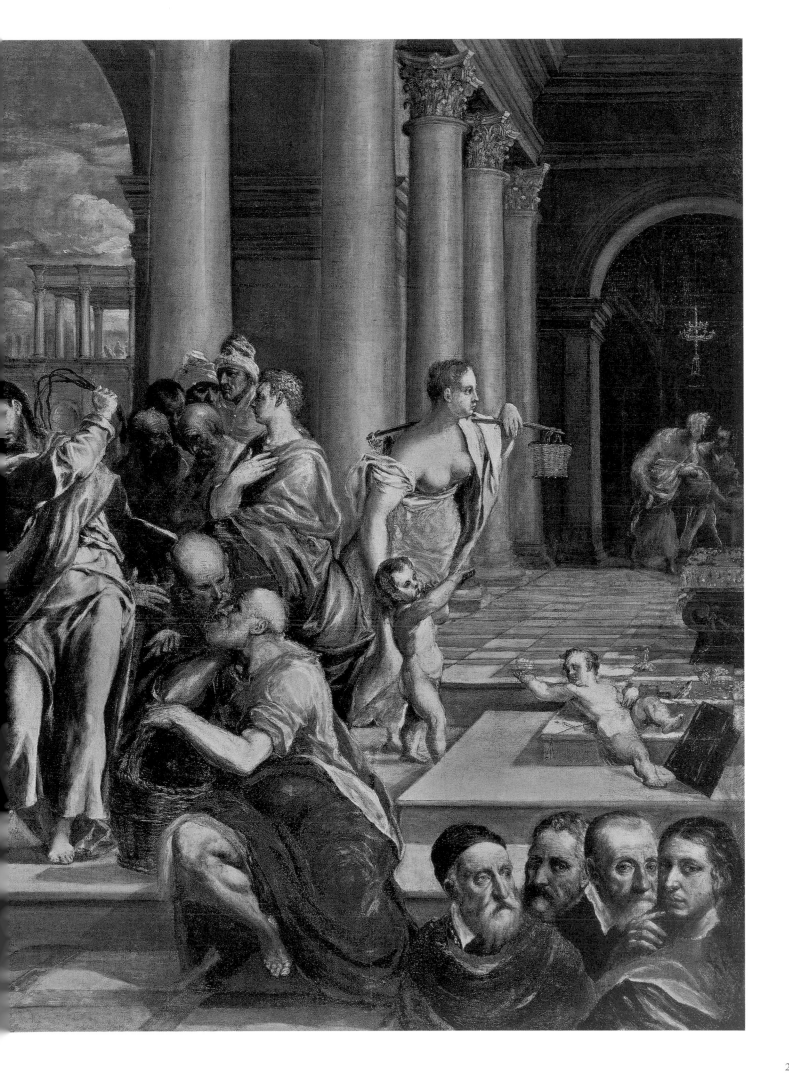

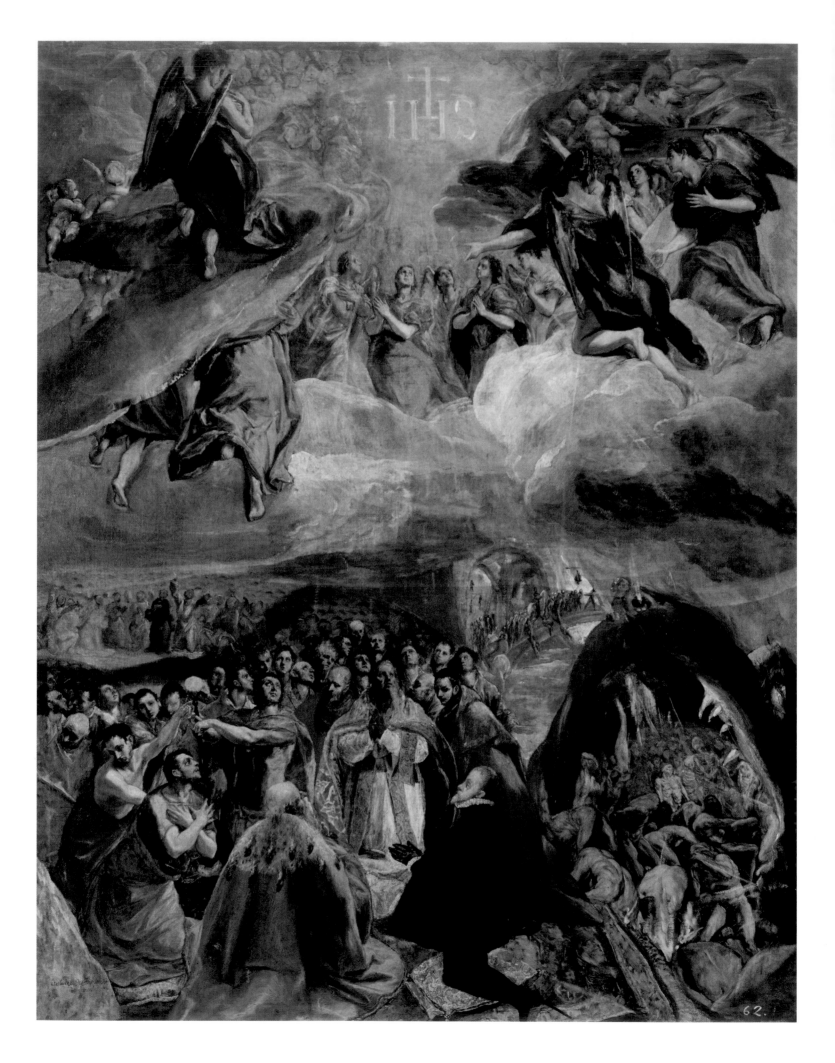

himself for the first time. This made it possible for him to open his own workshop in the papal city, which he did at the end of the year with the help of the Sienese artist Lattanzio Bonastri da Lucignano (c. 1550–c. 1590). Later they were joined by the Italian painter Francesco Prevoste (c. 1528–1607), who would subsequently accompany El Greco to Spain.

A work that underscores El Greco's link with Titian for Rome's benefit is the *Mary Magdalen in Penitence* in Budapest (ill. p. 27). Various dates have been ascribed to the picture. The lagoon landscape with the two islands and the 16th-century ointment jar of Venetian glass point to Venice. Another feature that speaks against the picture's execution in Spain is the sensuous interpretation of the figure of Mary Magdalen with her barely covered breast. As we shall see, the holy female figures done later, in Toledo, were rendered with greater decorum.

Between September 1572 and October 1576, when El Greco was first recorded in Spain, there are no further documents mentioning his name. What did he do during this period, and by what paths did he arrive on the Iberian Peninsula?

Let us begin with the second question. To answer it, we must first remember that about 30,000 Spaniards lived in Rome at the time, constituting about one quarter of the total estimated population of 115,000. Furthermore, the Habsburg rulers of Spain invested a great deal of money in papal elections to ensure that candidates favourable to their interests would prevail. One of their key allies in this regard was the Farnese family, in whose palazzo El Greco had resided.

The Farnese librarian and El Greco supporter mentioned above, Fulvio Orsini, was befriended with the Spanish humanist Pedro Chacón, who in turn is recorded to have met Luis de Castilla in Rome in summer 1571. Luis de Castilla was to become one of El Greco's closest friends after having obtained several commissions for him in Toledo during the artist's early years in Spain. Still other possible contacts are conceivable which perhaps led El Greco straight to the Escorial, at that period the largest construction site in the entire Christian world.

For to this day it remains to be explained how El Greco's painting *The Adoration of the Name of Jesus* came to Spain (a second, smaller version of which now hangs in the National Gallery in London; ill. p. 24). In terms of content, the composition seems based on a Bible text from St Paul, as was already noted in a 17th-century source. Yet in addition to the adoration of Christ described by St Paul, for which there were predecessors in painting, a group of figures arranged in a circle in the foreground strikes the eye. The figure clad entirely in black is doubtless identifiable as King Philip II. If we interpret the gentleman in the yellow robe in front as a doge of Venice, the elderly man opposite him as a depiction of the pope, and the gentleman with sword on the left as Don Juan de Austria, victor in the naval battle of 1571 against the Turks at Lepanto, it becomes clear that a second theme is interwoven into the picture here. This might conceivably be an *Allegory of the Holy League*, an alliance of Catholic powers which made this significant military victory possible. Veronese, too, painted an *Allegory of the Battle of Lepanto* in Venice in 1572, and even though El Greco was no longer in Venice at the time, his example points up how attractive the subject was at that period.

Possibly the Greek artist wished to recommend himself for further commissions by depicting Philip II. The scholars gathered at the Escorial, who remained in close contact with their Roman colleagues around Fulvio Orsini, may have served as intermediaries. Among them was the significant court humanist to the king of Spain, Benito Arias Montano, who is known to have exerted influence on the decoration of the monastic residence on other occasions as well.

The Adoration of the Name of Jesus, 1577–1579
Oil and tempera on pine,
57.8 x 34.2 cm (22.8 x 13.5 in.)
London, The National Gallery

The Adoration of the Name of Jesus,
c. 1577–1579
Oil on canvas, 140 x 110 cm (55.1 x 43.3 in.)
Monasterio de San Lorenzo de El Escorial,
Patrimonio Nacional

Several indicators suggest that El Greco wished to recommend himself to Philip II with this painting. One is the high quality of the pigments employed, which was revealed by a cleaning.

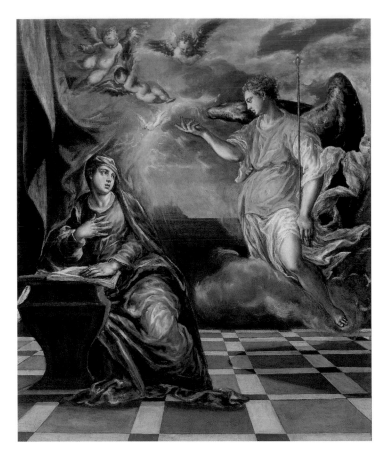 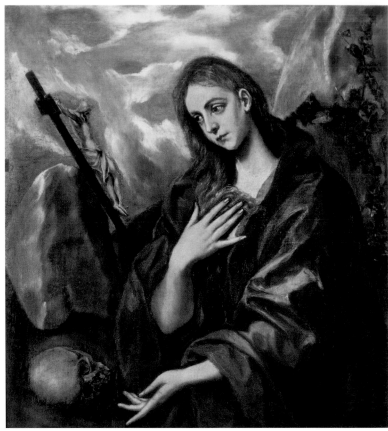

LEFT:
The Annunciation, c. 1575
Oil on canvas, 117 x 98 cm (46.1 x 38.6 in.)
Madrid, Museo Thyssen-Bornemisza

RIGHT:
Mary Magdalen in Penitence, 1585–1590
Oil on canvas, 109 x 96 cm (42.9 x 37.8 in.)
Sitges, Museo Cau Ferrat

Before the great upswing experienced by Baroque art around 1600, economic problems in Italy on the one hand, and the competition among local artists on the other, forced numbers of Italian artists to seek work abroad. The most promising destination was Spain, which due primarily to her military might at that time held a dominant position in Europe. Thanks to her silver imports from Latin America, Spain also had capital at her disposal. Considerable funds were indeed necessary, because Italian artists had achieved great social prestige and their works were therefore relatively expensive. El Greco had recognized this opportunity early on, which made him, almost involuntarily as we shall see, a champion of the rights of Spanish artists, who back then were often looked upon in their own country as mere artisans.

One of those who followed him, perhaps inspired by his example, was Federico Zuccari (c. 1541–1609), an Italian painter best known for his theoretical treatise on art. He had perhaps already met El Greco in Rome. At any rate, Zuccari too went to Spain, stayed three years at the Escorial (1585–1588), and returned richly rewarded (ill. p. 20).

PAGE 27:
Mary Magdalen in Penitence, c. 1576
Oil on canvas, 164 x 121 cm (64.6 x 47.6 in.)
Budapest, Szépmüvészeti Muzeum

In terms both of the monumental figure and certain smaller details, such as the right hand with middle and ring finger held together, this picture shows parallels with Titian (ill. p. 67). Even the landscape is anticipated in some of Titian's drawings.

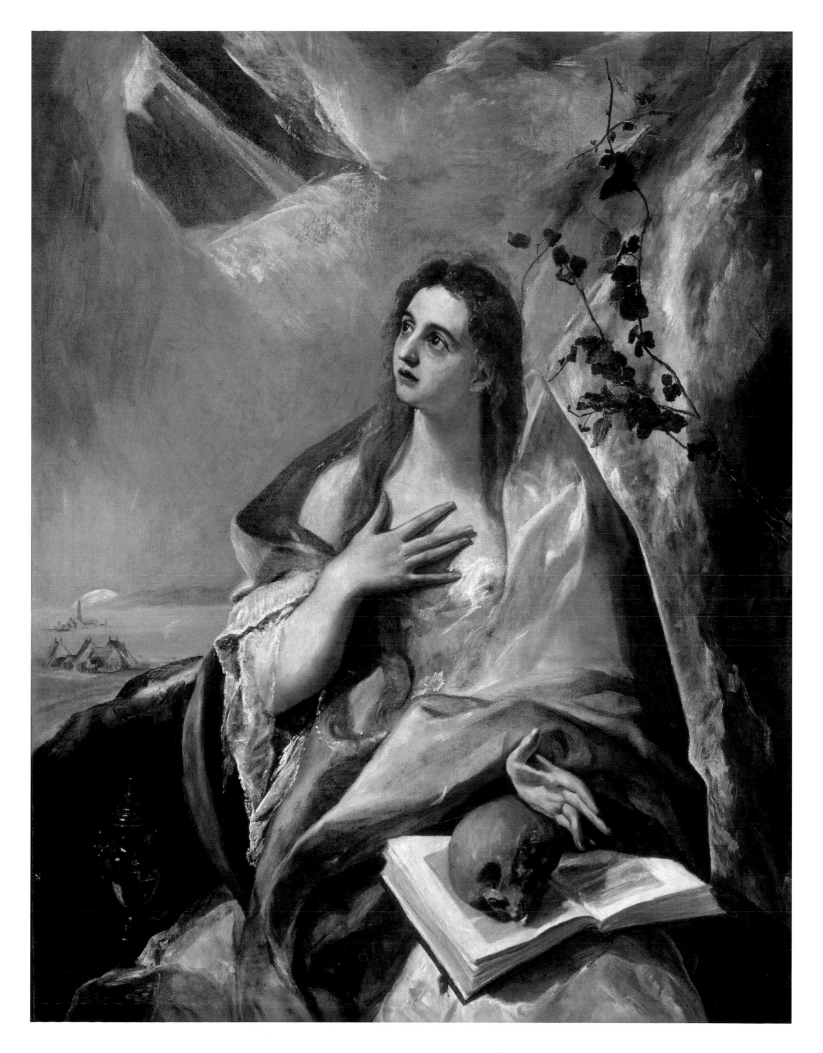

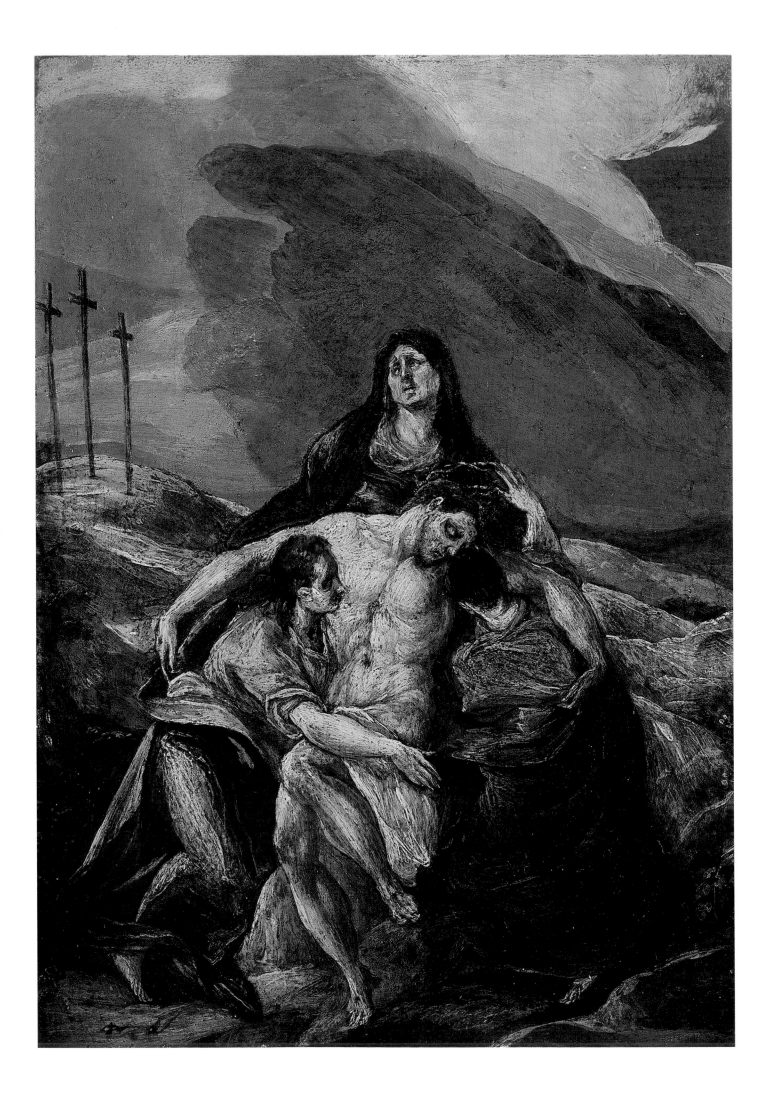

Under the Sway of Michelangelo

What, then, did El Greco do in Italy between 1572 and 1576? It has been suggested that he returned once again to Venice, yet this assumption would seem improbable. An important argument to the contrary rests on the fact that at this period, and in his earliest works in Spain, the artist clearly adhered to the style of that master whose most renowned work in Rome he had just considered painting over: Michelangelo.

This is indicated by a *Pietà*, once again executed on panel (ill. p. 28). El Greco's painting contains references to more than one work by Michelangelo, the clearest being to a sculpture group of around 1550 on the same theme, which is now in Florence but back then was still in Rome (ill. p. 29). The artist probably relied here, too, on an engraving based on the sculpture and incorporating the Calvary and the nails in the foreground.

Unlike Michelangelo, at the apex of the compositional triangle El Greco placed a figure of the Virgin rather than Joseph of Arimathia, in whom Michelangelo had portrayed himself. Moreover, the Greek from Candia lent his picture a drama which appeals to the viewer's emotions in a thoroughly Baroque way, whereas the Florentine's more reserved sculpture aims largely at evoking a meditative mood. This dramatic element is augmented in a later, somewhat larger version on canvas, which was perhaps not executed until shortly before El Greco left for Spain.

In El Greco's day Italy was divided into very diverse political units, whose artists tended to represent quite different approaches to painting. Perhaps the greatest contrast obtained between the Venetian painters, who in the wake of Titian figured as advocates of a luminous, flowing handling of colour, or *colore*, and the Roman artists who, with Michelangelo, gave precedence to drawing, or *disegno*, and with it a painting schooled on the sculptural models of classical antiquity. When El Greco arrived on the Iberian Peninsula, the "disciple of Titian" visibly changed camps, and with his first two commissions in Toledo – paintings for three retables in the monastery church of Santo Domingo el Antiguo (ill. p. 94) and a *Disrobing of Christ* for the sacristy of the cathedral (ill. p. 36) – he created key examples of this linear Roman style, if without entirely belying his Venetian heritage.

In the case of Santo Domingo el Antiguo, Diego de Castilla, deacon of Toledo Cathedral and father of Luis de Castilla, served as patron. The artistic programme was adapted to the needs of a funerary chapel. On the high altar, an

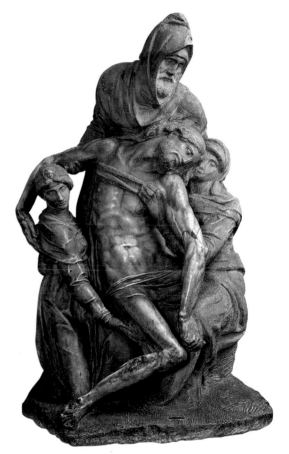

Michelangelo
Pietà, c. 1550
Marble, height 226 cm (89 in.)
Florence, Museo dell'Opera del Duomo

Pietà, early 1570s, Oil on panel,
28.9 x 20 cm (11.4 x 7.9 in.)
 Philadelphia, Philadelphia Museum of Art,
The John G. Johnson Collection

Both very much in Michelangelo's manner are the monumental presence of the group, which is further underscored by the modest format, and the corporeality of the figure of Christ, unusual when compared with El Greco's earlier work.

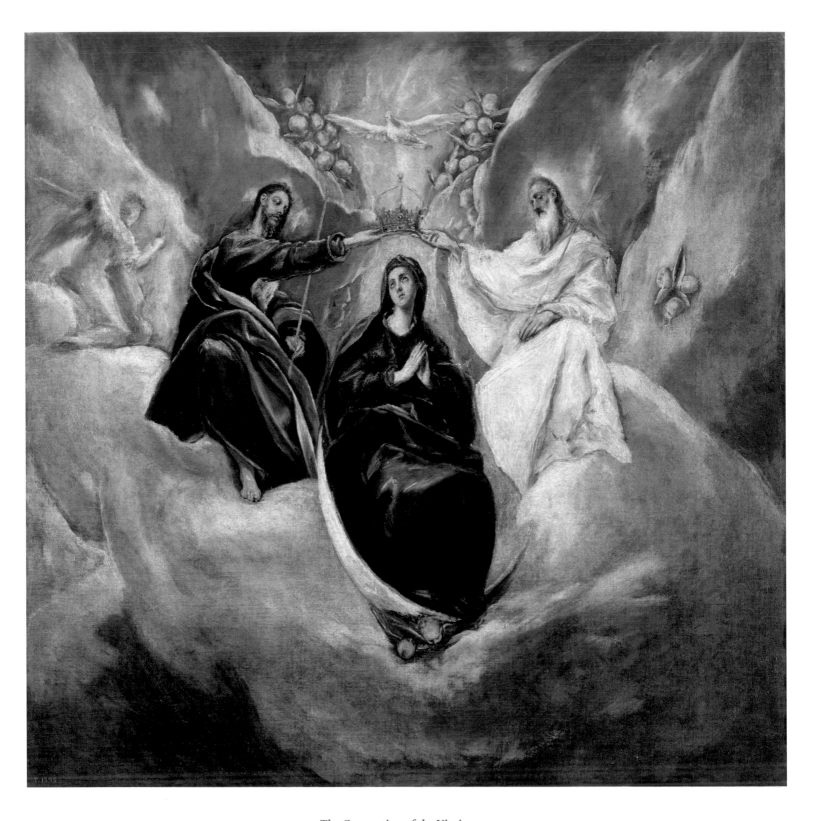

The Coronation of the Virgin, 1591
Oil on canvas, 90 x 100 cm (35.4 x 39.4 in.)
Madrid, Museo Nacional del Prado

PAGE 31:
The Assumption of the Virgin, 1577
Oil on canvas, 401 x 229 cm (157.9 x 90.2 in.)
Chicago, The Art Institute of Chicago

Mary appears in her traditional colours of red and blue, precisely on the vertical axis
of the picture, while the greens which would now become characteristic of El Greco
are arranged diagonally and set key complementary accents.

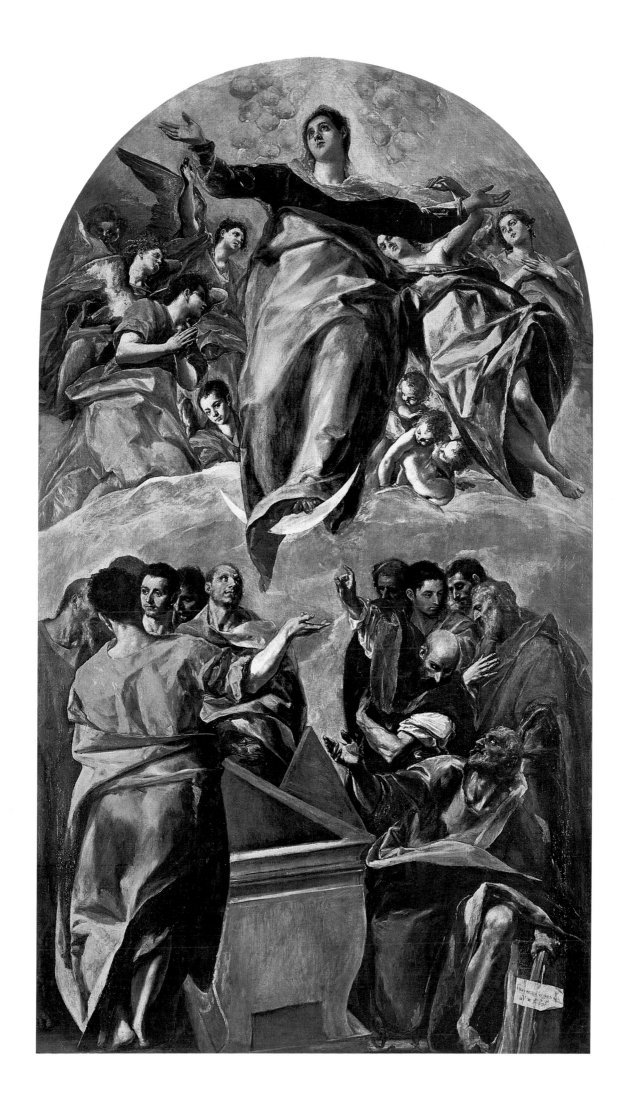

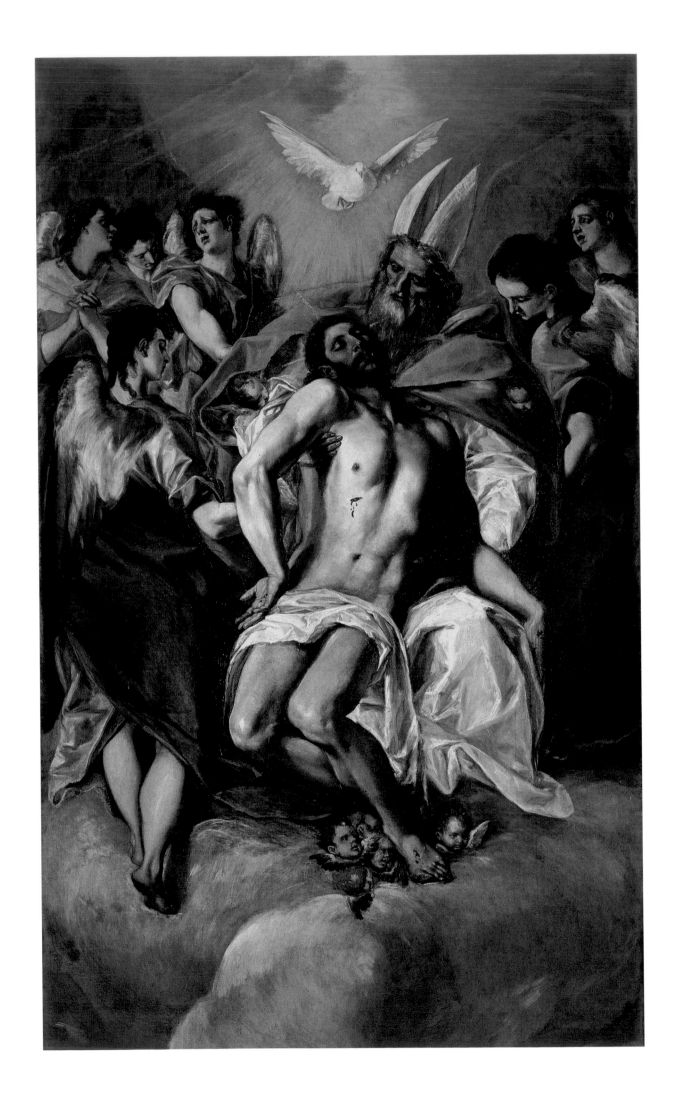

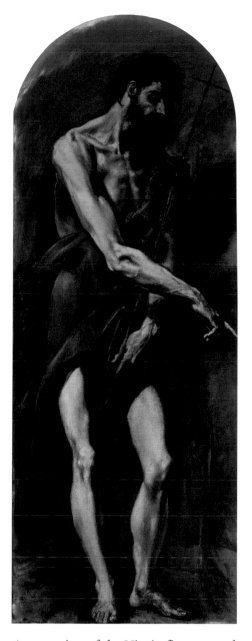

LEFT:
St John the Baptist, 1577–1579
Oil on canvas, 212 x 78 cm (83.5 x 30.7 in.)
Toledo, Santo Domingo el Antiguo

RIGHT:
St John the Evangelist, 1577–1579
Oil on canvas, 212 x 78 cm (83.5 x 30.7 in.)
Toledo, Santo Domingo el Antiguo

Assumption of the Virgin figures as the main image (ill. p. 31). This is framed by full-length depictions of *St John the Baptist* and *St John the Evangelist* (both p. 33) and two busts of *St Bernard* and *St Benedict*. Above these, in the pediment, is a depiction of *St Veronica Holding the Veil*, and on a further level, another large-format painting representing *The Trinity* (ill. p. 32). Depicted on the two smaller flanking retables are, on the left, an *Adoration of the Shepherds* with St Jerome and, on the right, the *Ascension of Christ* with St Ildefonso (ill. p. 94).

El Greco was not only responsible for the paintings but was asked to submit designs for the architecture of the retable, its decorative carvings and a tabernacle. In view of the works we have considered from Crete and Italy, what El Greco accomplished in his first Spanish project in the space of only two years, 1577–1579, is more than astonishing. Not only did he meet his clients' expectations but he created a work that would impress many generations to come. In 1776, for instance, Antonio Ponz wrote in his several-volume *Travels through Spain*, an inventory of the country's art treasures before the catastrophic destruction wrought by the Napoleonic occupation, that "these paintings alone ensure El Greco the highest fame among painters."

In order to attain to this high level of quality, thorough preparations were necessary. An idea of his efforts is conveyed by three preliminary drawings, one

PAGE 32:
The Trinity, 1577–1579
Oil on canvas, 300 x 178 cm (118.1 x 70.1 in.)
Madrid, Museo Nacional del Prado

In this depiction of the Holy Trinity, El Greco again relied on Michelangelo's *Pietà* as a model, although the immediate source was a woodcut by Albrecht Dürer.

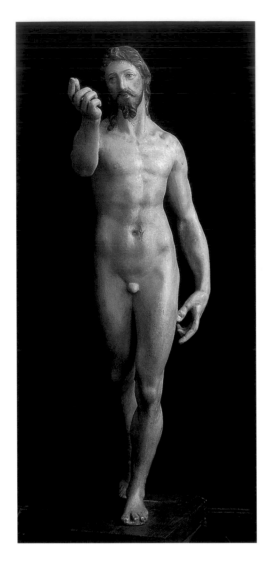

The Risen Christ, c. 1595–1598
Polychrome wood, height 45 cm (17.7 in.)
Toledo, Hospital Tavera

This figure clearly goes back to a design by El Greco, even though he himself may not have executed it. In Spain, every sculpture was given polychrome treatment, and the present figure of Christ still bears the original paint application.

of John the Baptist and two of John the Evangelist. Entirely in keeping with artistic practice in Rome, El Greco seems to have given *disegno* a key function in his working process, because the 1614 inventory of his estate includes 150 drawings. On the other hand, drawings were never highly valued by Spanish collectors, so that only a few works in this medium have survived, which sadly holds for El Greco as well.

In his first design the artist positioned the two St Johns in niches, and depicted St John the Evangelist in profile, gazing towards *The Assumption*. In contrast, the drawing from the Biblioteca Nacional shows him in the same pose as in the painting, turned frontally towards the viewer. Yet here, too, an alteration was made: in the final painting El Greco left out the eagle, John's symbolic animal.

When we compare the *The Assumption of the Virgin* (ill. p. 31) with the famous painting on the same subject by Titian in the Frari Church in Venice, it becomes clear how new were the paths El Greco took in Spain. Under the influence of Michelangelo he not only found an unusually naturalistic style with monumental figures, but adopted a palette tending towards that of the Roman school. The great luminosity of the painting is striking, an illumination that, probably not coincidentally, conforms with the real light falling on it from above.

In *The Trinity* we again find the cool and contrasting gradations of blue, green and yellow, while additionally white comes in to play a dominant role (ill. p. 32).

The same clarity of composition, finally, is also found in the architectural framework. Here El Greco relied on the models of church façades and portals. The lucid classicist forms he chose stand in strong contrast to the plateresque style – a richly detailed type of building ornament similar to the silversmith's art – that then still predominated in Spanish architecture. The sole parallel to El Greco's artistic vision is found, not coincidentally, in the strictly mathematical designs of the Escorial's second architect, Juan de Herrera. El Greco, it would seem at this juncture, came at just the right moment to help a fundamental reform of the Spanish arts to its breakthrough.

PAGE 35:
The Resurrection, late 1590s
Oil on canvas, 275 x 127 cm (108.3 x 50 in.)
Madrid, Museo Nacional del Prado

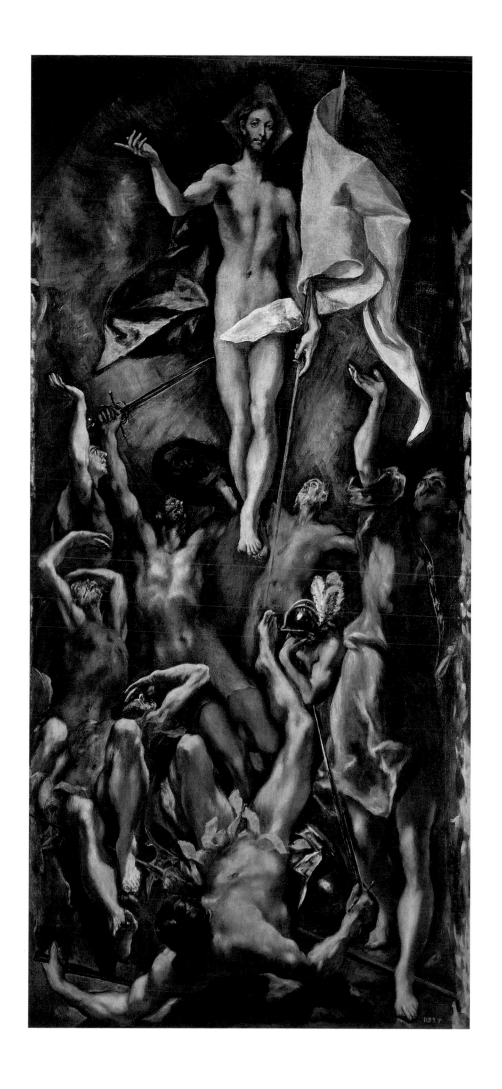

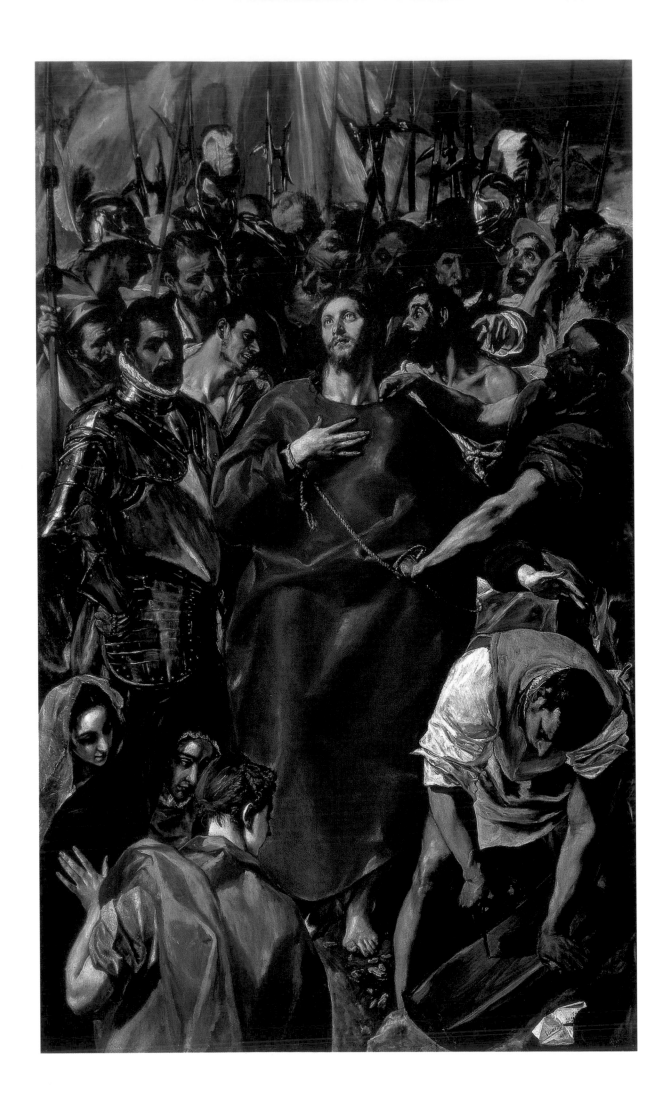

Censorship and Inquisition

The obstacles that would neverthless be placed in the way of the stranger from Greece first became evident in connection with his second important commission, the contract for which he actually signed a month before that for Santo Domingo. *The Disrobing of Christ* (ill. p. 36) was also commissioned by Diego de Castilla, but others were involved in deciding on the price to be paid. The picture with the considerable dimensions of 285 x 173 cm (112.2 x 68.1 in.) was executed for a room in Toledo Cathedral where the priests changed into their liturgical vestments before mass.

As in the case of the two main paintings for Santo Domingo el Antiguo, *The Disrobing* is a lucid composition in which the main figure is placed on the central axis and the treatment of the sky emphasizes this centre. Above Christ's head a funnel of clouds appears to open, yet the way is barred by a phalanx of lances.

The event depicted has no source in the Bible, but is mentioned in other Christian texts. In preparation for the crucifixion, Christ is stripped by a man clad in green on the right. In front of him, a man is drilling holes in the cross for the spikes. The three Marys observe these preparations in the left foreground, and above them stands a man in armour who might represent Longinus.

At that period in Spain, payment for works of art was undertaken on the basis of an estimation of the finished work. Artist and client named experts who made price recommendations. If they were unable to reach an agreement, a mediator was brought in. In the case of Santo Domingo, El Greco himself reduced the envisioned fee from 1,500 to 1,000 ducats. For *The Disrobing of Christ*, the artist's representatives suggested a price of 900 ducats, while the cathedral representatives were willing to pay only 227 ducats.

It is interesting to consider the reasons advanced for this unusually large discrepancy. To reduce El Greco's fee, the clients resorted to arguments of content. Canon García de Loaysa, representing the Church, demanded that the picture be altered, thinking it most unseemly that certain heads in the crowd projected above the figure of Christ and that the Marys were present at the scene despite their not being mentioned in the Bible.

In the case of Santo Domingo el Antiguo, too, Diego de Castilla had the contractual right to decide upon the final content of the composition: "If one of these pictures is not satisfactorily executed in part or in whole, the said Dominico shall be required to correct it or make it anew, such that the work shall be

Christ Carrying the Cross, c. 1600–1605
Oil on canvas, 108 x 78 cm (42.5 x 30.7 in.)
Madrid, Museo Nacional del Prado

PAGE 36:
The Disrobing of Christ, 1577–1579
Oil on canvas, 285 x 173 cm (112.2 x 68.1 in.)
Toledo, Cathedral sacristy

The painting was moved to the converted sacristy in 1612, that is, during El Greco's lifetime. In the 1790s it received a new frame, in which it is still displayed today.

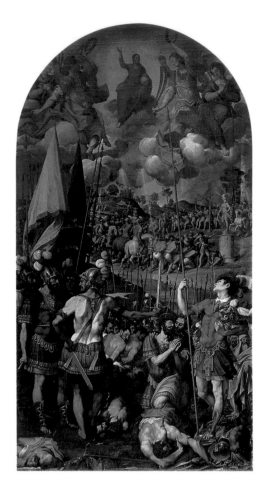

Romulo Cincinnato
The Martyrdom of St Maurice, after 1582
Oil on canvas, 540 x 288 cm (212.6 x 113.4 in.)
San Lorenzo de El Escorial, Monastery Church

El Greco received 800 ducats for his painting of this subject, while Cincinnato received only 550 ducats. Paradoxically, Cincinnato had previously arbitrated the fee for his colleague's work, since the representatives of the King and the artist were unable to reach an agreement.

PAGE 39:
The Martyrdom of St Maurice, 1580–1582
Oil on canvas, 448 x 301 cm (176.4 x 118.5 in.)
Monasterio de San Lorenzo de El Escorial,
Patrimonio Nacional, Nuevos Museos

In a simultaneous depiction, we see St Maurice twice, clad in the same garment both times. In the foreground the figure looms large and is turned toward the viewer. In the middle ground the saint provides consolation as a companion is about to be beheaded.

perfect and acceptable to Don Diego. ..." And as an analysis of the preliminary drawings has shown, changes were in fact made, perhaps – although this is only speculation – to conform with the client's wishes. Subjecting artists to this type of control still reflected the old idea that they were mere artisans. But in Italy, as noted, artists had in the meantime acquired a higher social status which put them on a level with representatives of the liberal arts – that is, the sciences – and made an individual style of some sort veritably a requisite. El Greco had come to artistic maturity in this milieu, and as a result viewed himself, in Spain as previously in Italy, as an inventor of original works rather than merely an executor of others' ideas. This caused him difficulties for the first time in connection with his *Disrobing*, and would do so on many future occasions.

At any rate, the foreigner El Greco seems not to have been entirely willing to bow to local customs. The first agreement, in September 1579, according to which he was to receive 317 ducats, was only temporary. A more elaborate compromise soon followed: in 1585 he was commissioned to fabricate a frame for his picture, including a three-dimensional scene depicting the Virgin passing a garment to St Ildefonso. In Toledo this was an important subject, once more alluding to the function of the sacristy. For this project, a new agreement estimating the price at 535 ducats was reached in 1587, and the artist received the money before the year was out. That the fee for the frame far exceeded that for the painting was not only due to the circumstances, but reflected the higher value that sculpture still enjoyed over painting in Spain at the time. This was an important reason why El Greco always strove, as in his first two commissions, to execute the three-dimensional frame as well. In the end, the offending iconographic peculiarities remained uncorrected, and this despite the fact that the painting hung in a prominent place, in the main church of the most important archbishopric on the Iberian Peninsula.

His success in Toledo must have been an extraordinary experience for El Greco after all his years of vagabondage, great ambitions and small commissions. Unlike the key masters of the Italian Renaissance, he did not reach this point until an advanced age – he was going on 40. At this age Raphael was already dead, and Titian and Michelangelo had mighty potentates as patrons at a comparable phase of their life. Apparently El Greco wanted too much too soon in this situation, and abandoned the caution that had guided him during his early years in Spain and that had brought him, the foreigner, his surprising recognition.

His next significant painting, *The Martyrdom of St Maurice* (ill. p. 39), accordingly reflected an astonishing change in style. In place of the naturalism that had marked his works for Santo Domingo el Antiguo and the *Disrobing of Christ*, he chose an approach which quite clearly showed an attempt to express spiritual phenomena. His works of the 1580s show an increasing disregard for Renaissance rules of perspective and proportion. The figures lose plasticity, become slender and elongated. As we know from Pacheco, El Greco prepared his compositions not with live models but, like Tintoretto, with clay figurines. The illumination took on a symbolic function, light and dark came to stand in a marked contrast to each other, and the colours began to take on a more expressive character.

El Greco's miscalculation lay in his trying out this new technique in precisely the painting where his naturalistic style would have been most welcome – his second trial picture for the Escorial. With this palatial structure Philip II pursued the ambitious intention of conveying the reformist ideas of the Catholic

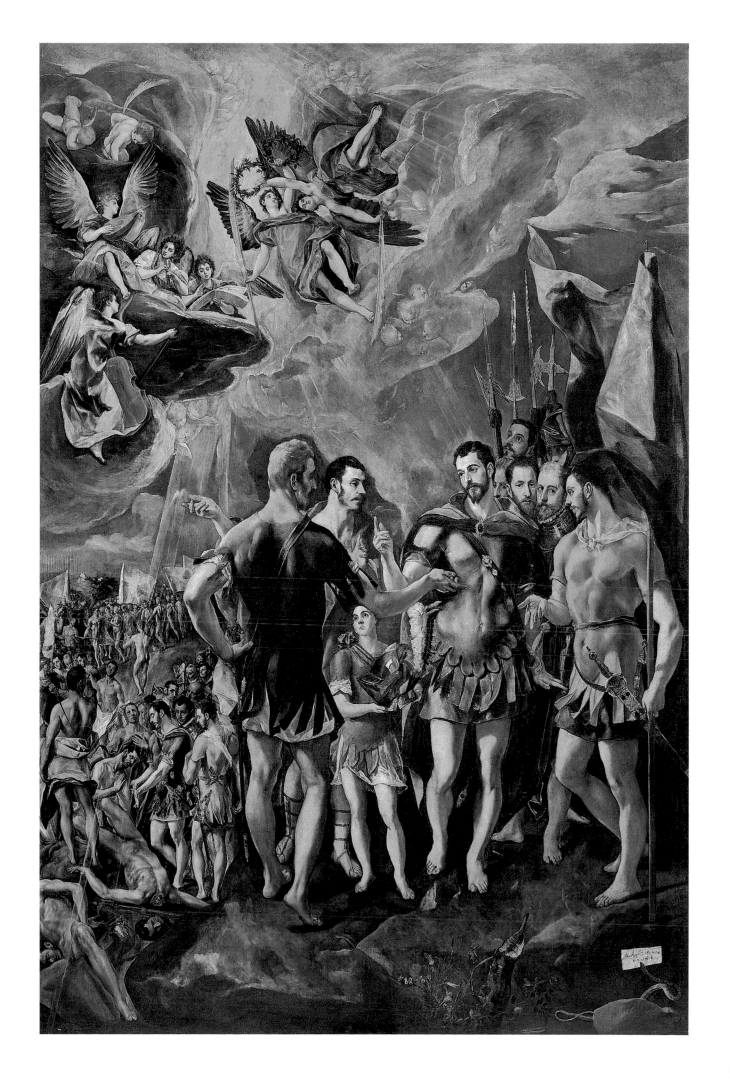

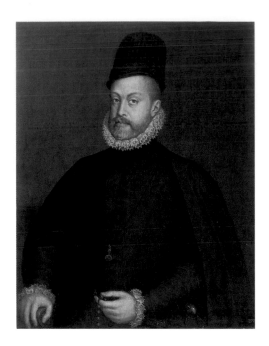

Sofonisba Anguissola
Philip II Holding a Rosary, 1573
Oil on canvas, 88 x 72 cm (34.7 x 28.4 in.)
Madrid, Museo Nacional del Prado

Sofonisba Anguissola (c. 1530/35–1626) was called to Madrid in 1559 to serve as lady-in-waiting to Queen Isabella. There she executed numerous portraits of the family of Philip II which, due to a lack of written sources, can be attributed to her only on the basis of stylistic comparisons.

Council of Trent (1545–1563), which he himself had materially influenced. The cornerstone for the Escorial was laid in the final year of the Council, and from then on, the king had great difficulties not only with his architects but with his choice of artists for the decoration. What he really wanted was a single painter who would execute both the high altar and the numerous side altars in a uniform style. His initial choice was Juan Fernández de Navarrete, a pupil of Titian who ideally conformed with the Tridentine decree on painting, which demanded the greatest possible clarity of design. But Fernández de Navarrete had died prematurely, and it would seem that Philip II, after seeing El Greco's first trial picture, *The Adoration of the Name of Jesus* mentioned above (ill. p. 24), envisioned the Greek artist as a possible replacement.

Thanks to the chronicler of the construction of the Escorial, Padre José de Sigüenza, an Hieronymite monk who initially held the office of librarian and later that of abbot, we are unusually well informed about what the king expected of his painter Fernández de Navarrete: "The saints should be painted in a way that does not rob one of the desire to pray before them." El Greco supplied an artful painting, but not the reformed confessional propaganda Philip II would have wished: "From a Dominico Greco, who now lives in Toledo and makes outstanding things, a picture remained here of St Maurice and his soldiers, which he executed for the altar of that saint; it did not please His Majesty, and that is no wonder, for it pleased few; although they say it contains much art and that its author knows a great deal, which one sees in outstanding things from his hand."

According to legend, under Diocletian's co-ruler Maximian Maurice commanded a unit of troops who, due to their Egyptian origin, were called the Theban Legion. Their confession of Christian faith led them to forswear idol worship, and so, consoled by the saint, the legion was beheaded to a man.

In contrast to *The Disrobing of Christ* (ill. p. 36), this time El Greco put in the centre of the composition not the martyrdom, but a conversation accompanied by rhetorical gestures, a sort of "Sacra Conversazione." Angels in heaven celebrate the sacrifice of the martyrs with music, wreaths and palm fronds.

Although Philip II paid for the picture, he declined to place it on the altar of the Escorial church, for which it had originally been intended. Above all, he gave no further commission to El Greco. Instead, he had a new painting on the same subject executed by Romulo Cincinnato (ill. p. 38). Since both works have survived, we can gain a good idea of the king's points of criticism. Surprisingly, there is a great conformance between the two pictures in terms of composition, so we may assume that Cincinnato was asked follow El Greco's model. A difference, on the other hand, is seen in Cincinnato's stronger emphasis on the execution scene, which has been brought into the foreground. Also, the king may have disapproved of the inclusion of a living person in an historical scene, although this was a familar feature of El Greco's paintings. The figure in a cuirass to the right of the saint probably represents Emanuel Philibert, Duke of Savoy and Grand Master of the Order of St Maurice, and victor in the battle that led to the building of the Escorial. Cincinnato, finally, dispenses with a number of learned allusions – the flowers of sanctity (*flos sanctorum*) in the foreground referring to the martyrdom, the cross formed by the arms of the angels carrying wreaths, etc. – with which El Greco shows himself to be more an exponent of the intellectual art of Florence and Rome than the painter of clear messages desired by the Council of Trent.

The definite change of style seen in *The Martyrdom of St Maurice* is also found in other El Greco works of this period. Evidently, the artist drew no

conclusions from his unfavourable experiences at the Escorial. It is revealing, for instance, to compare the approach to the figure in *St Sebastian*, 1577/78 (ill. p. 44) with *The Crucifixion with Two Donors*, c. 1580 (ill. p. 43). In the latter, El Greco possibly relied on a three-dimensional crucifix by the sculptor Benvenuto Cellini (1500– 1571), which the artist presented to Philip II for his new palace and which did not appeal to the king either.

The king's interventions in artistic matters and his connections with the Council of Trent naturally call to mind the old cliché of a Spain entirely in the grip of the Inquisition. The emergence of this notion was due partly to Italian artists who, perhaps disgruntled at having to seek work in a foreign and supposedly uncultured country, circulated jokes and legends about it. Vasari, for instance, reported in his *Lives of the Artists* that the Italian sculptor Pietro Torrigiano (1472–1528) – another migrant who had to flee Italy because he had smashed Michelangelo's nose – destroyed one of his sculptures out of anger at the meagre price paid by the Spanish patron who had ordered it. Thereupon

The Agony in the Garden, c. 1590–1595
Oil on canvas, 102.2 x 113.7 cm (40.2 x 44.8 in.)
Toledo (Ohio), Toledo Museum of Art

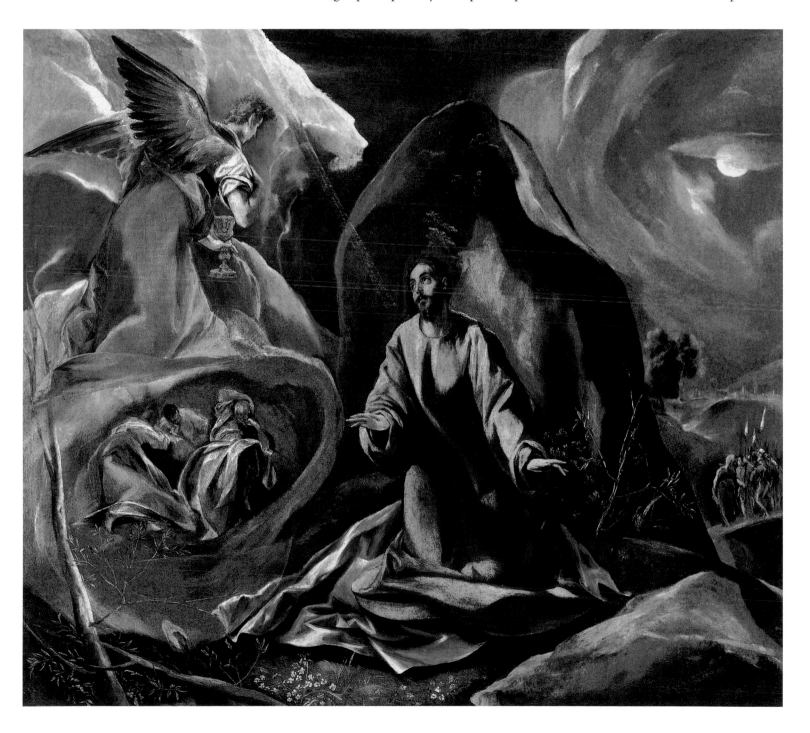

he was supposedly denounced as a heretic to the Inquisition and finally, after a
hunger strike, died in its dungeons. However, no concrete evidence for any of
these statements has been found to this day.

At any rate, Philip II did not throw El Greco into a dungeon, nor did he have
his picture destroyed or altered. He simply found it unsuited to its intended site
or, to use a key term of the day, the painting did not conform with the *decoro*,
or decorum, required in the Escorial church. It was the same reason for which
modest loincloths were added to Michelangelo's *Ignudi*, or nude figures, in *The
Last Judgement* in the Vatican Sistine Chapel.

On the other hand, the king apparently appreciated the artistic qualities of
El Greco's picture – after all, he paid generously for it – and, in the process, made
a distinction still very new at that date: that between an altar painting and a col-
lector's painting. This distinction enabled him to become the most important
collector of Hieronymus Bosch, despite widespread doubts as to the Netherland-
er's orthodoxy. Nothing faced Father Sigüenza, the chronicler, with more prob-
lems than explaining this passion on the part of his monarch.

In fact the example of El Greco would seem to prove the opposite of intoler-
ance, namely the astonishingly strong capacity for integration that Spanish so-
ciety still possessed at the end of the 16th century. The reforms put in practice at
the beginning of the century, under the influence of Erasmus of Rotterdam, for
a short time made the Spain of the Escorial the spearhead of a new confessional
era, which for far too long has been associated with the one-sided and now

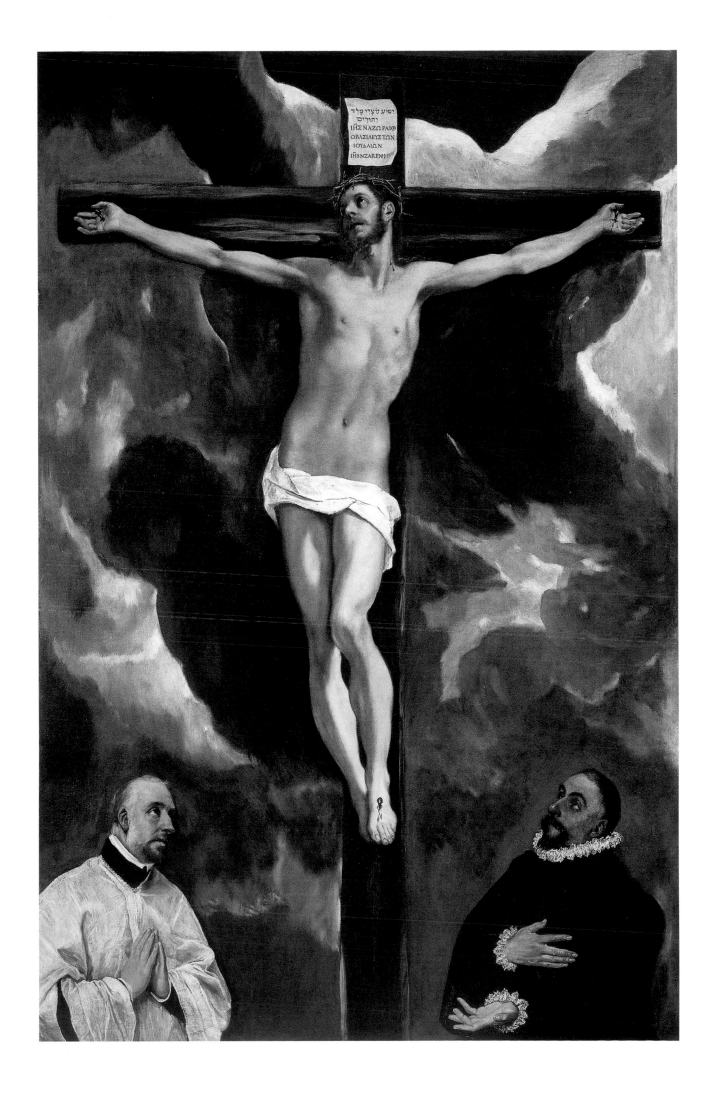

43

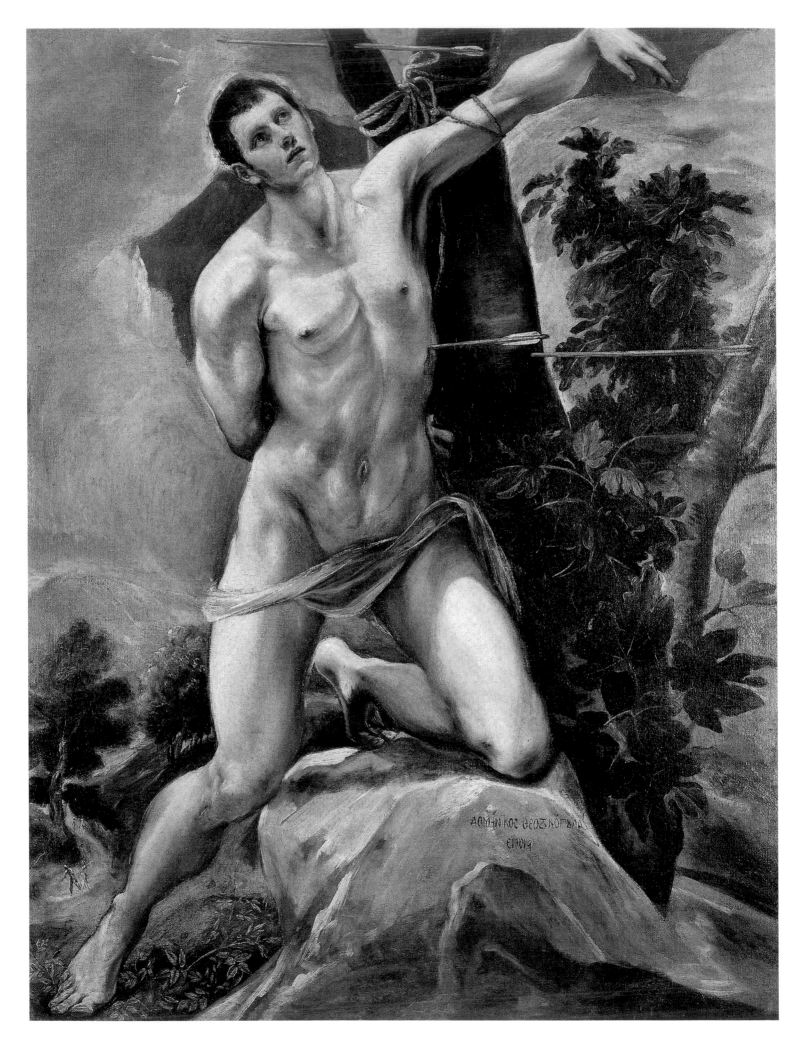

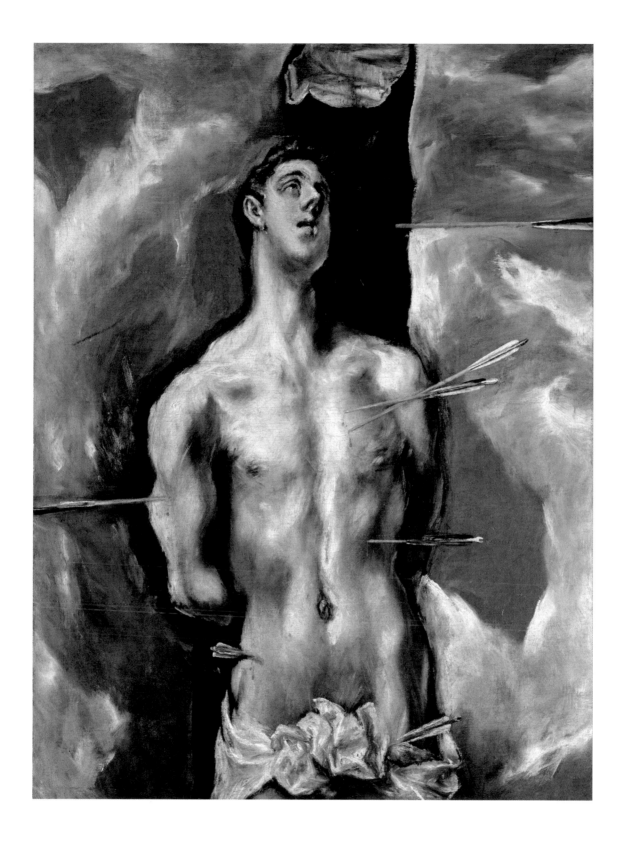

St Sebastian, 1608–1614
Oil on canvas, 115 x 85 cm (45.3 x 33.5 in.)
Madrid, Museo Nacional del Prado

PAGE 44:
St Sebastian, 1577/78
Oil on canvas, 191 x 152 cm (75.2 x 59.8 in.)
Palencia, Museo Catedralicio

The Palencia St Sebastian was El Greco's first life-size depiction of a nude.
It was based on Michelangelo as well as on the renowned Greco-Roman statue
of Laocoön, which the artist had evidently studied in the original.

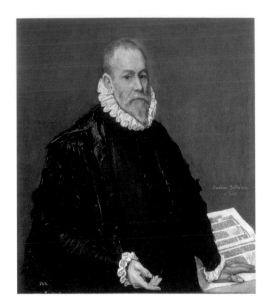

Rodrigo de la Fuente, c. 1588
Oil on canvas, 93 x 82 cm (36.6 x 32.3 in.)
Madrid, Museo Nacional del Prado

PAGE 47:
St Louis, King of France, with a Page, 1590s
Oil on canvas, 120 x 96.5 cm (47.2 x 38 in.)
Paris, Musée du Louvre

obsolete concept of the Counter-Reformation. With the aid of liberal church circles, here and only here was the foreigner El Greco able to develop early expressions of the Baroque pictorial language that would obtain widespread prevalence only in the 17th century.

· Still, Toledo was not free of intolerance. It was in the city on the Tajo that a discussion began on the statute of *limpieza de sangre*, or purity of blood, something that El Greco's patron Diego de Castilla bitterly opposed. In Toledo Archbishop Bartolomé Carranza was accused and incarcerated by the Inquisition, but when his innocence was proven shortly before his death in 1576, his portrait was hung alongside that of his predecessor in the chapterhouse of the cathedral. It was not until the reign of Philip III, who drove the Moors out of Spain for good in 1609, that Spain began to follow its separate path, continuing throughout the 17th century to fight religious wars while the greater part of Europe, in the wake of the devastating Thirty Years' War, found its way to a new policy of tolerance (ill. p. 48).

In El Greco's day the Spanish Inquisition, installed in 1483, was only one factor in a policy of isolation that accompanied the growing religious conflicts all over Europe, and it had relatively clearly defined limits and tasks. The stranger from Greece is recorded to have had dealings with it on two occasions. These were very different, both in kind and significance.

In the first case, it was merely a matter of assisting a Greek countryman at a court trial. Between May and December 1582, El Greco served as an interpreter at nine Inquisition sessions. A 17-year-old Greek servant from Athens, Micael Rizo Calcandil, had been charged with heresy, but was finally found innocent.

The other case was more remarkable. It concerned El Greco's second serious attempt, after his failed submission to the Escorial, to gain one or more significant patrons, this time among the Toledo clergy. His trial painting was a full-length portrait of *A Cardinal* (ill. p. 49), probably Fernando Niño de Guevara, who at the time of painting, around 1600, was Grand Inquisitor in Toledo.

The churchman is depicted seated in a wooden armchair, in a three-quarter view facing the spectator. He wears the red cardinal's cape whose collar (*mozetta*), buttoned in front, both isolates and heightens the head capped by a biretta. The cape falls open above the knees, revealing an exquisite lace-trimmed surplice, whose filigree white is repeated as accents on the collar and sleeves. Of the feet one sees only the tips of two brown shoes. The gestures of the hands, one dangling open and the other gripping the arm of the chair, suggest conflicting urges in the sitter's state of mind. In the background, on an extension of the body's axis, a black strip separates the pattern of wooden coffering on the left from the shimmering gold of the leather wall-covering on the right. The pattern on the floor, like a system of coordinates, defines the spatial relationships in the picture and lends stability to the scene: a horizontal rectangle marks the Cardinal's sitting position and a dark circle frames a paper bearing the artist's signature.

The provocativeness of the portrait is due primarily to the round spectacles, fastened to the ears by threads. These were not a device which El Greco used to reveal the sitter's intolerance, as one author could still maintain after 1900, but represented an important technical innovation at a period when many still doubted the propriety of wearing eyeglasses or favoured a pince-nez. This and further information is found in one of the earliest encyclopedias on eyeglasses, published of all people by a notary for the Spanish Inquisition, Benito Daza de Valdés, in 1623 in Seville.

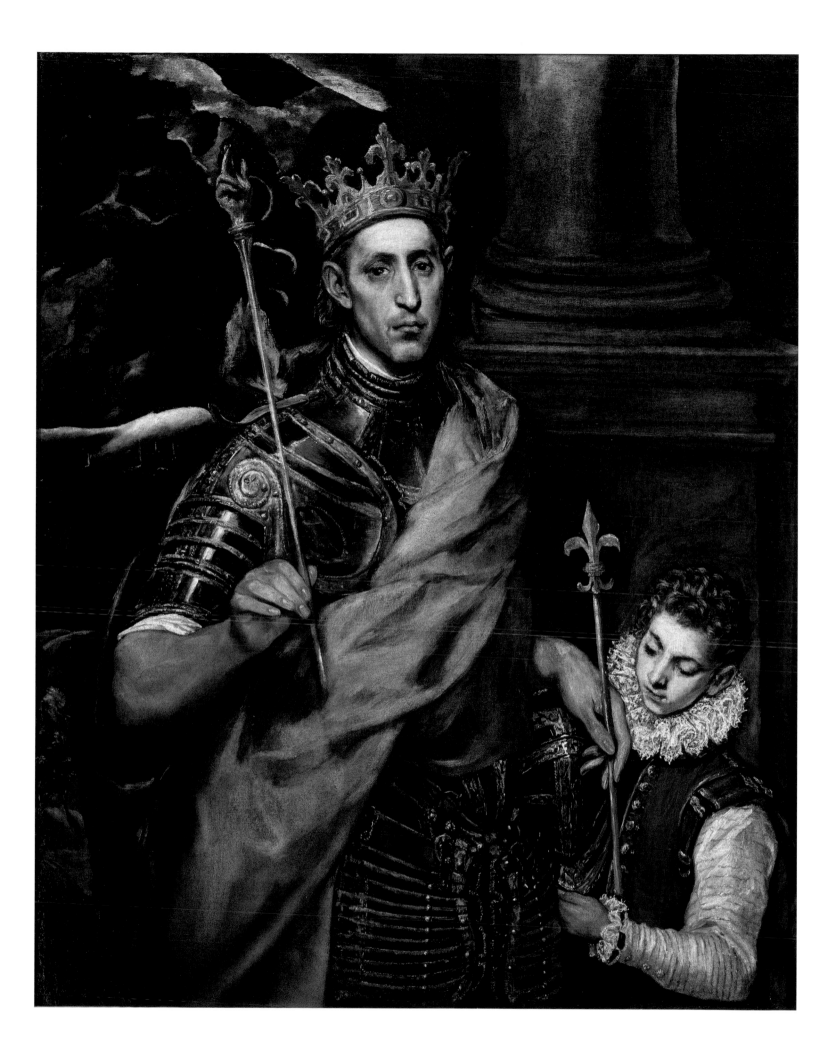

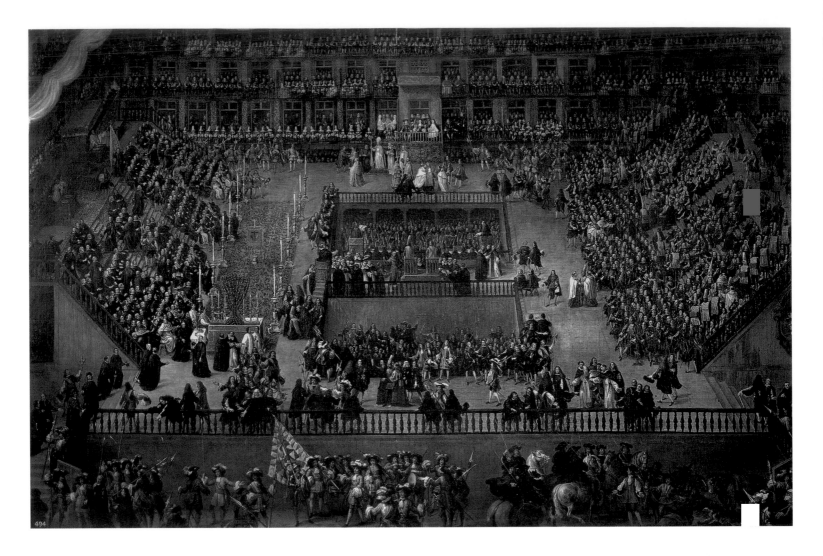

Francisco Rizi
Auto-da-fé on Plaza Mayor, Madrid, 1683
Oil on canvas, 277 x 438 cm (109.1 x 172.4 in.)
Madrid, Museo Nacional del Prado

Rizi's painting is impressive for its format alone.
It shows one of the last great autos-da-fé in
Madrid, held in the presence of King Charles II
in 1680. Economically bankrupt, Spain was no
longer in a position to contribute to the battle
against the Turks, so the supposed heretics with-
in the country's borders were persecuted all the
more severely.

So as a comparison with the contemporaneous fashions in glasses shows,
this is a Grand Inquisitor who proves his own power of judgement and his ad-
miration for technical advances in a dual sense: not only did he choose to be
portrayed by El Greco, whom Philip II had rejected on account of his idiosyn-
cratic style, but he sat for him wearing the most advanced eyewear of the day.
This man could in fact have been of great use to El Greco, but he was sadly
demoted in 1601, to the office of Archbishop of Seville.

PAGE 49:
**Portrait of a Cardinal, Probably Cardinal Don
Fernando Niño de Guevara)**, c. 1600-1604
Oil on canvas, 170.8 x 108 cm (67.2 x 42.5 in.)
New York, The Metropolitan Museum of Art

The vibrant light reflections playing across
the exquisite material of the cape and surplice
form a striking contrast to the angularity of
the wooden armchair, whose rigidity seems to
have communicated itself to the Cardinal.

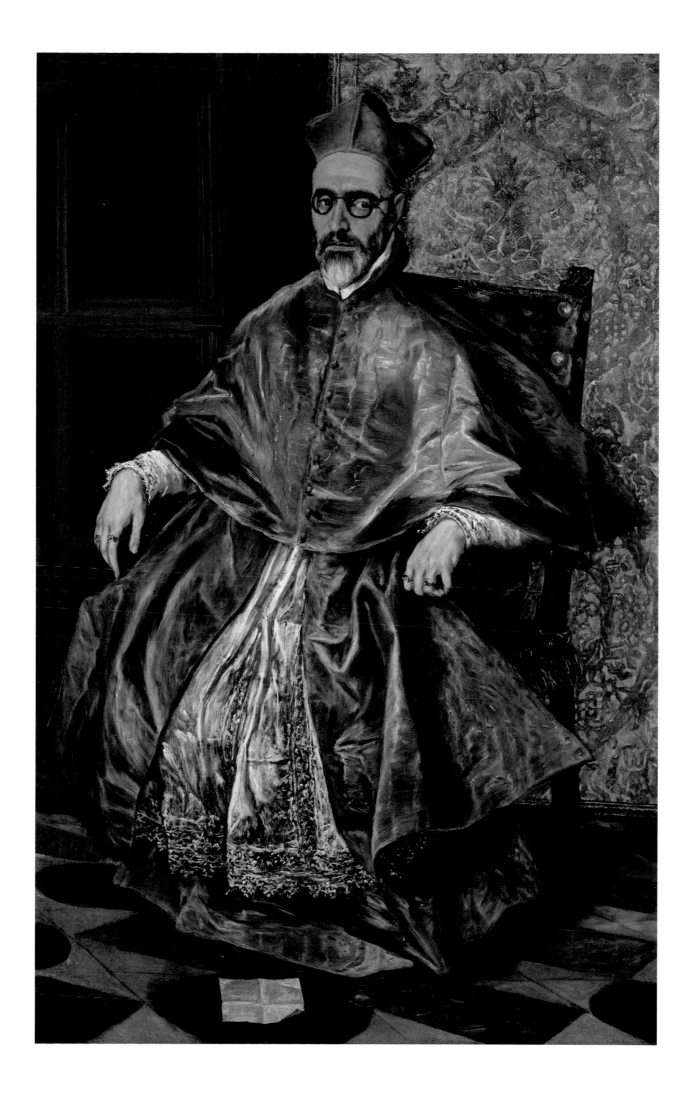

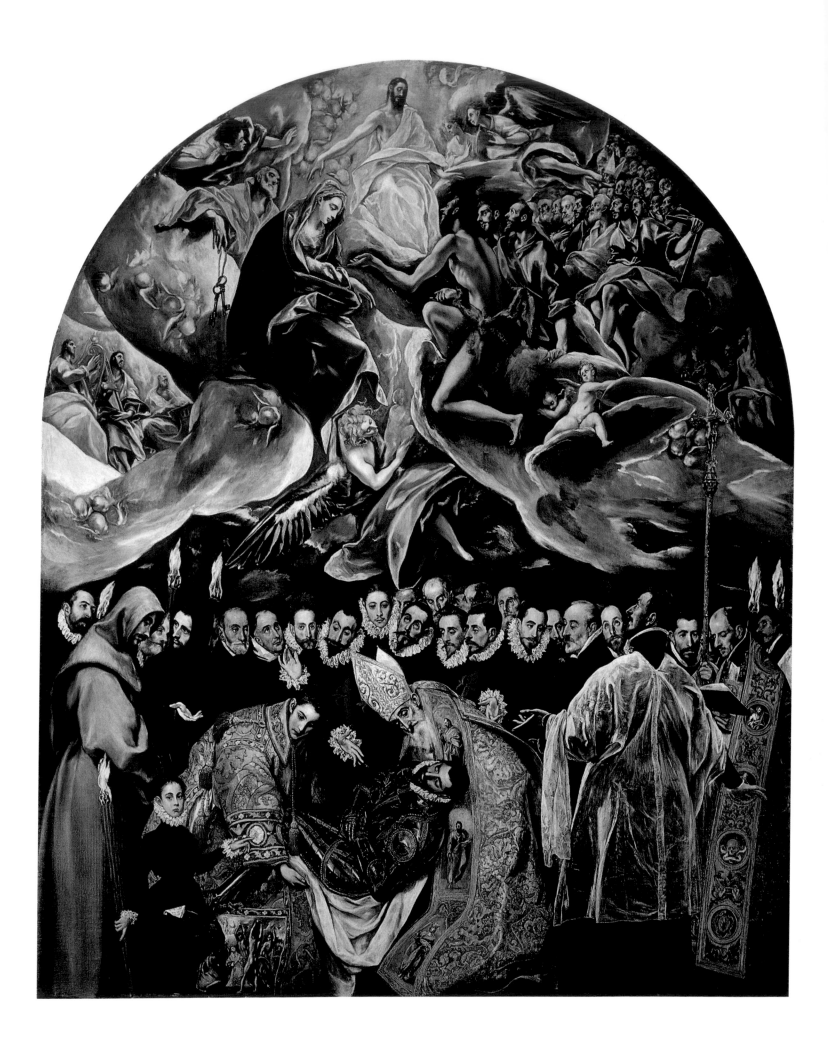

Toledo, the Artist's New Home

El Greco's dashed hopes of becoming a court painter to Philip II only strengthened his ties with Toledo. On 10 September 1585, he rented three sets of rooms in the Marqués de Villena's former palace, including the spacious "royal apartments". In 1578 Jerónima de las Cuevas had borne him a son, whom they named Jorge Manuel after El Greco's father and brother. Following the early death of his wife, El Greco lived with his son in the new quarters until 1590, then again from 1604. The palace, no longer extant, has nothing to do with today's "Casa y Museo de El Greco" and supposedly stood on the present site of the Paseo del Tránsito, in what had once been the Jewish quarter of Toledo. A document of 1589 mentions the artist as a *vecino* (inhabitant) of the city.

El Greco's new roots in Toledo are symbolized most clearly by what is probably his best-known painting, *The Burial of the Count of Orgaz* (ill. p. 50). With the commission, issued on 18 March 1586, the priest of his own parish of San Tomé, Andrés Nuñez de Madrid, frankly pursued financial interests. When Gonzalo de Ruiz, Conde de Orgaz, died in 1327, he left a will stipulating that an annual donation be made to Santo Tomé by the citizens of Orgaz, which their descendants now refused to pay. By recalling the burial with an inscription and a painting the clergyman hoped to revive this old privilege. His most persuasive argument was provided by the depiction of a miracle which raised the Conde almost to the status of a saint. Legend had it that St Stephen and St Augustine had appeared personally at the funeral to bury the pious count.

The Greek artist's picture is divided into two clearly distinguished zones. In the lower section we see a funeral of a kind that could have taken place in contemporary Toledo. The two saints – Stephen identified by a scenic depiction of his stoning in Dalmatia – are bearing Count Orgaz to his grave, as a figure to their right, probably the patron Andrés Nuñez, reads the requiem. In the upper section, an angel leads Orgaz's soul, depicted as a child, through a sort of birth canal of clouds to heaven, where it is awaited by Christ Pantocrator, St John and the Virgin as intercessors, and a number of other saints.

El Greco's new artistic orientation, his abandonment of the concepts of the Roman High Renaissance, is reflected here especially in the handling of the lighting, which is entirely symbolic in effect. The heavenly sphere is dominated by a restless oblique light, while the earthly realm confronts the viewer as a uniformly illuminated stage on which the torches, surprisingly, seem to give off little real light.

PAGE 50:
The Burial of the Count of Orgaz, 1586–1588
Oil on canvas, 480 x 360 cm (189 x 141.7 in.)
Toledo, Church of Santo Tomé

This painting is one of the key points of pilgrimage for travellers to Spain who want to see El Greco in the original. As one of Picasso's confrères reported, "How many hours we spent full of admiration in studying El Greco's *Burial of the Count of Orgaz*!"

Antonio de Covarrubias, c. 1600
Oil on canvas, 67 x 55 cm (26.4 x 21.7 in.)
Toledo, Casa y Museo de El Greco

Antonio de Covarrubias, with his brother Diego, belonged to the Spanish delegation at the Council of Trent. He was supervisor of the University of Toledo and was considered a moral and intellectual authority throughout Spain.

PAGE 53:
Fray Hortensio Félix Paravicino y Arteaga,
c. 1609
Oil on canvas, 112.1 x 86.1 cm (44.1 x 33.9 in.)
Boston, Museum of Fine Arts,
Isaac Sweetser Fund

The sitter, famed as a poet and rhetorician, was a friend of the renowned court poet Luis de Góngora. Here he presents himself in the black and white habit of the Trinitarian Order with its bluish red cross.

Among the mourners, one is clearly identifiable: the white-haired man depicted in profile on the right is Antonio de Covarrubias y Lieva (1524–1602), a close friend of El Greco's and one of the most learned men of the period. The artist proclaimed his admiration for his friend, with whom he probably communicated in his native tongue, Greek, in the marginal notes he made in his books. That he is represented in the *Burial* may be gathered from a comparison with a further portrait, painted by El Greco around 1600, when Covarrubias had gone completely deaf (ill. p. 52). The depiction can be taken as a confirmation of the traditional claim that El Greco immortalized other fellow-citizens of Toledo in the figures of the mourners. Also, it is generally agreed that the boy at the front edge of the picture represents the artist's eight-year-old son, because El Greco signed the painting on the boy's handkerchief with the date 1587, the year Jorge Manuel was born.

As far as type is concerned, the *Burial* is a group portrait, for which there was no parallel in contemporaneous Spanish art but which was concurrently developing into an especially popular genre in the Netherlands.

Related in kind to the portraits in the *Burial* is El Greco's *The Nobleman with his Hand on his Chest*, explaining why it has recently been dated to about the same period, c. 1583–1585 (ill. p. 54). A recent restoration brought to light a picture which is extremely rich in colour, both in the background and the attire, and which thus still stands in the Venetian tradition so crucial to El Greco's portraiture. Like Titian, but unlike the contemporaneous court painters in Madrid, El Greco moreover decided on a loose handling of the paint in which the brushstrokes remain visible in the final result.

On the other hand, the sitter's severe posture, his gesture of taking an oath, and the waiver of all extraneous symbolism with the exception of the gilded hilt of the sword, have long been viewed as a prime example of the notion of honour that has stereotypically been called an essential Spanish character trait since the end of the 19th century.

The sources are better in the case of the portraits of two other well-known Toledo personalities: Fray Hortensio Félix Paravicino y Arteaga (ill. p 53) and Jerónimo de Cevallos (ill. p. 55). Paravicino (1580–1633) was a Trinitarian monk whose family originated from Italy. At the young age of 21 he became professor of rhetoric at the University of Salamanca, one of the two most significant in Spain. His *Obras postumas, divinas y humanas*, published in 1641, contains a sonnet dedicated to the present painting, and four others in which the monk praises El Greco's art in general.

Cevallos (1562–1644) studied jurisprudence in Salamanca and worked as an attorney and author in Toledo. In 1623 he published the book *Arte real para el buen gobierno* (The Royal Art of Good Government), which was intended to help the new king, Philip IV, prevent the demise of the Hispanic world. In addition to the portrait, which was executed on the occasion of his marriage, a posthumous inventory of Cevallo's estate lists a *St Francis* by El Greco.

An example of El Greco's late work is provided by the *Portrait of Cardinal Tavera* (ill. p. 77), which arose around 1608–1614. Juan Pardo de Tavera (1472–1545) held both important ecclesiastical and political offices under Charles V, being active among other things as Grand Inquisitor and government chief of Castile. By the time of his portrayal, however, he had long been deceased.

When El Greco executed his first commissioned works in Toledo around 1577, the city was embroiled in a period of transition. Since the Visigoth period, apart from an interruption due to the Moorish occupation (712–1085), Toledo had

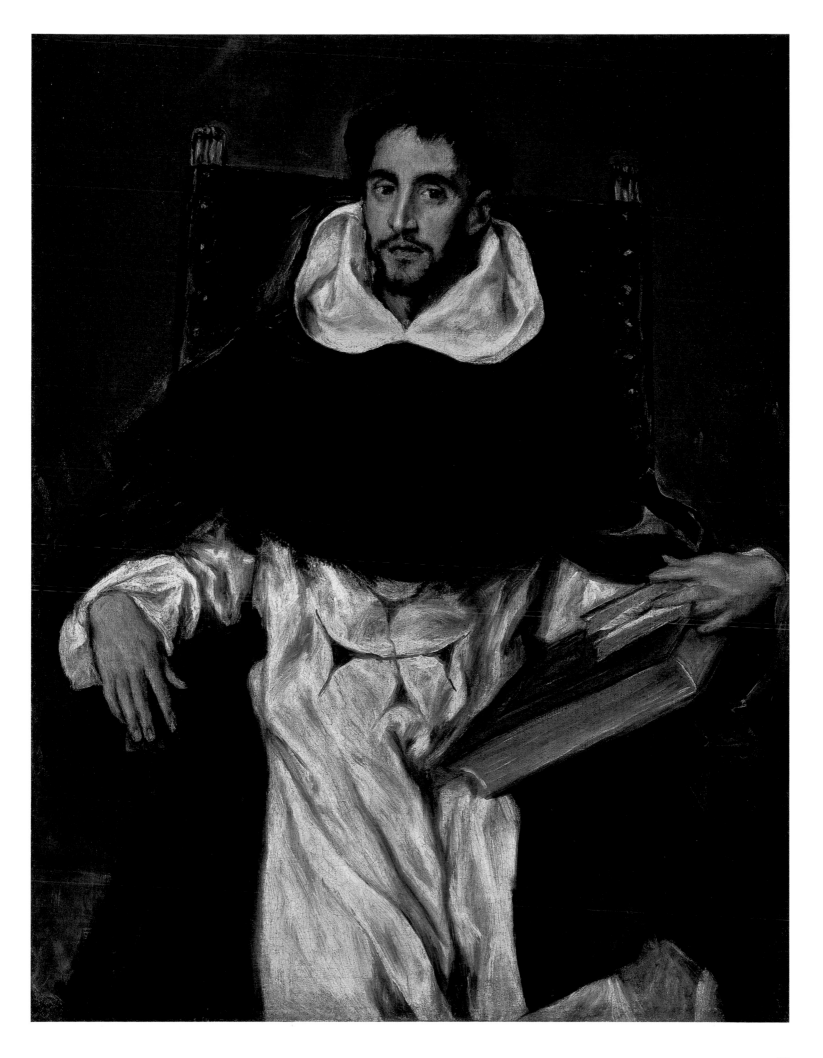

Nobleman with his Hand on his Chest, 1583–1585
Oil on canvas, 81 x 66 cm (31.9 x 26 in.)
Madrid, Museo Nacional del Prado

The nobleman depicted here with the gesture of swearing an oath
corresponded so perfectly to the stereotype of the Spaniard that many thought
he represented the greatest poet of the Siglo de Oro, Miguel de Cervantes.
In fact, the sitter's identity still remains to be determined.

Jerónimo de Cevallos, c. 1610
Oil on canvas, 70.8 x 62.7 cm (27.9 x 24.7 in.)
Madrid, Museo Nacional del Prado

A member of the city council and a prominent citizen of Toledo,
Cevallos frequently took part in the literary sessions held at the residence of the Count of Mora,
Francisco Rojas y Guzmán, where he exchanged opinions with many leading figures in the arts,
including the dramatist Lope de Vega.

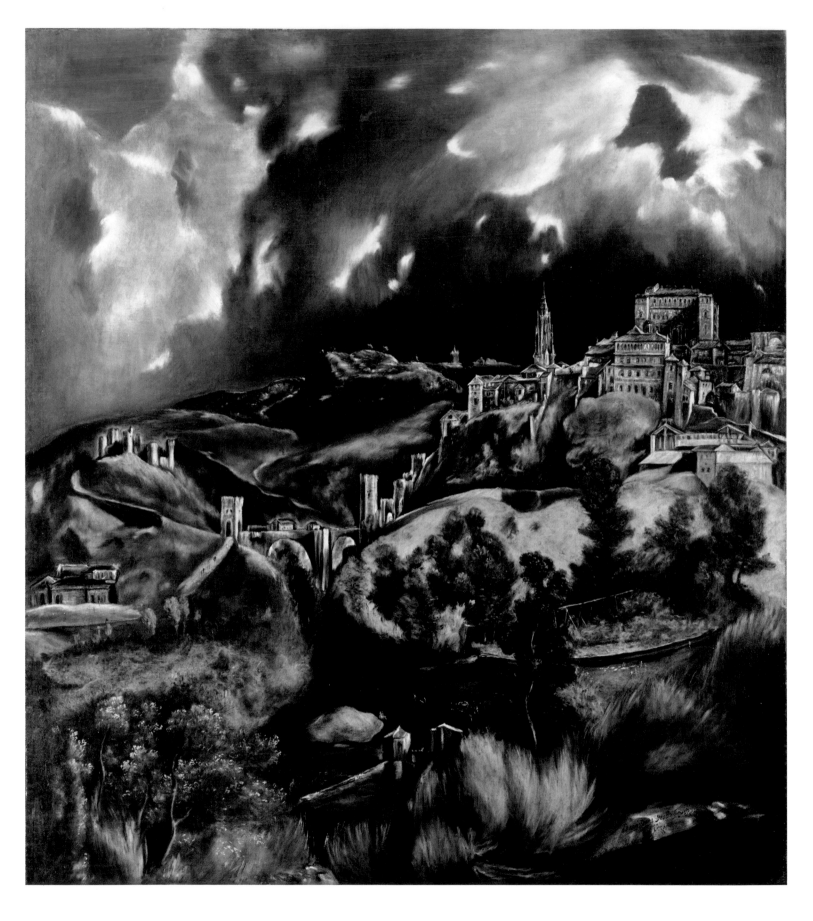

A View of Toledo, c. 1597–1599
Oil on canvas, 121.3 x 108.6 cm (47.8 x 42.8 in.)
New York, The Metropolitan Museum of Art

The four-storey building with arcades on the top floor, below the Alcázar,
has been read as a merely symbolic reference to the city's many aristocratic mansions,
since no corresponding actual building has been identified.

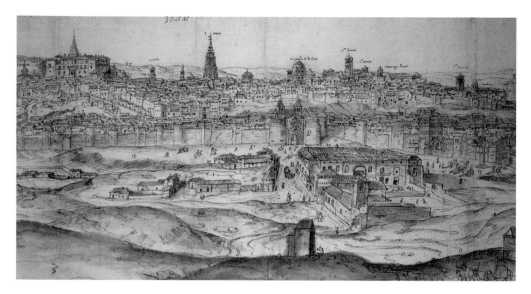

LEFT:
Anton van den Wyngaerde
View of Toledo (detail), 1563–1570
Wash drawing, 42 x 107,5 cm (16.5 x 42.3 in.)
Vienna, Österreichische Nationalbibliothek

BELOW:
El Greco's commentaries on Vitruvius' *De Architectura*, Madrid, Biblioteca Nacional

As his commentaries on Vitruvius show, El Greco concerned himself intensively with architecture, quite in accordance with the notion that a Renaissance artist should be knowledgeable in every field of visual art. The most famous example in this regard is Michelangelo.

functioned as a religious and secular centre for Christian Spain. In 1561 Philip II had decided to shift his seat of government to Madrid. Although the prosperity of Toledo, which counted all of 62,000 inhabitants in 1571, essentially rested on a flourishing textile trade and the revenues of the archbishop, the municipal government had no illusions about the economic significance of this move and did their utmost to regain the king's favour.

Key among their various activities was an urban reform of Toledo, commenced around 1570 and aimed at altering the medieval city with its tangled labyrinth of streets to meet the royal court's requirements for open spaces in which to hold processions and other events. The lack of these had been a key reason for the court's move to the then still provincial town of Madrid.

Amongst the projects undertaken in this connection was a redesign, by Juan de Herrera, of the main square, the Plaza de Zocodover, and the installation of a technically advanced piping system to supply the Alcázar with fresh water. Research suggests that El Greco's *A View of Toledo* (ill. p. 56), painted around 1597–1599, was intended both as an allusion to the glorious history of the city and a reference to its new image.

The idiosyncrasy of El Greco's view of the religious metropolis on the Tajo is revealed by a comparison with a painting that strove for historical accuracy, the 1563 *View of Toledo* (ill. p. 57) by Anton van den Wyngaerde, who portrayed a whole series of Spanish cities for Philip II. El Greco depicted only the eastern part of Toledo, with the Alcázar, Alcántara bridge and the castle of San Servando. He shifted the bell tower of the cathedral here from its actual location farther to the right. Above all, he dramatically emphasized the slope of the hill, left out the massive encompassing wall, and led the riverbed into the foreground of the picture, although it should actually flow out towards the left.

The suggestion that El Greco is here offering us a symbolic rather than literal view of his adopted city is lent support by his *View and Plan of Toledo* (ill. p. 58/59), dating to 1610–1614. In this canvas, an inward luminosity contributes to lending the city the look of an apparition of the Heavenly Jerusalem. Both cityscapes were likely in the possession of Pedro Salazar de Mendoza, an important figure in the city's religious life. Salazar de Mendoza was administrator of the Hospital de San Juan Bautista, founded by Tavera in 1541, and in this function had also commissioned the portrait of the Cardinal discussed above (ill. p. 77).

El Greco's special ties with Toledo are reflected in the way he repeatedly integrated individual motifs from the city in his depictions of saints, as in the large

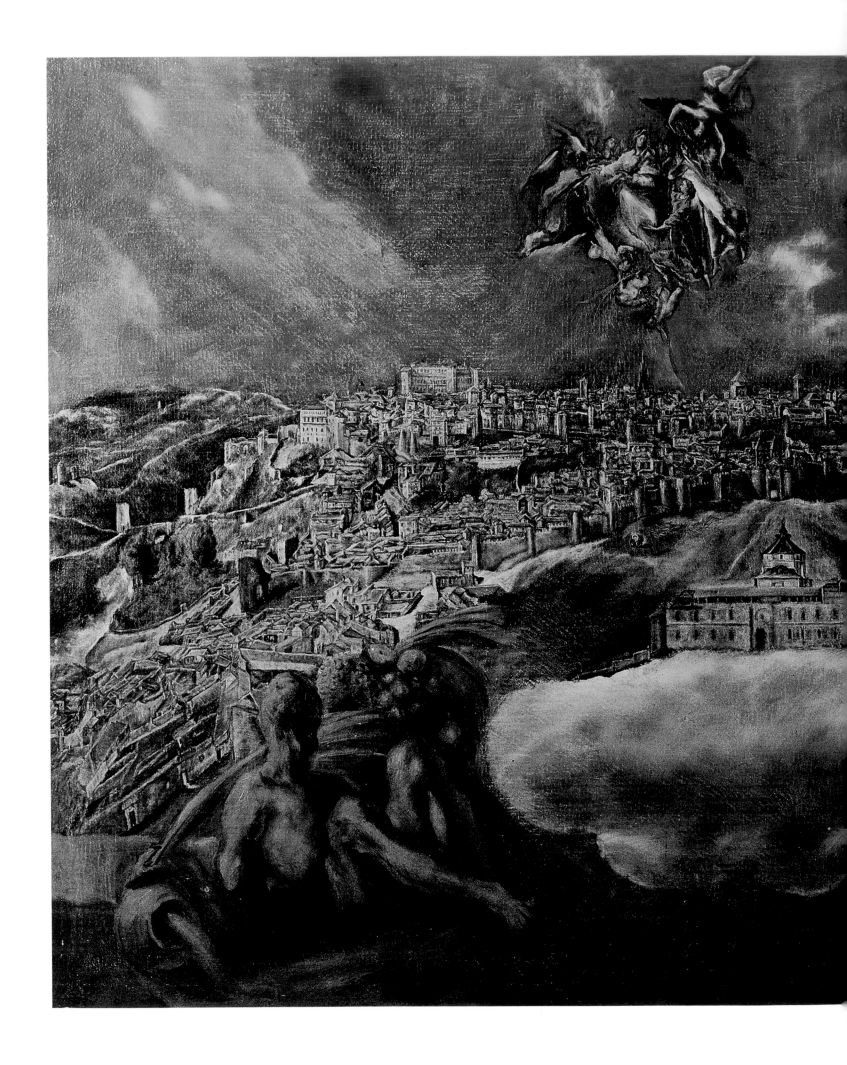

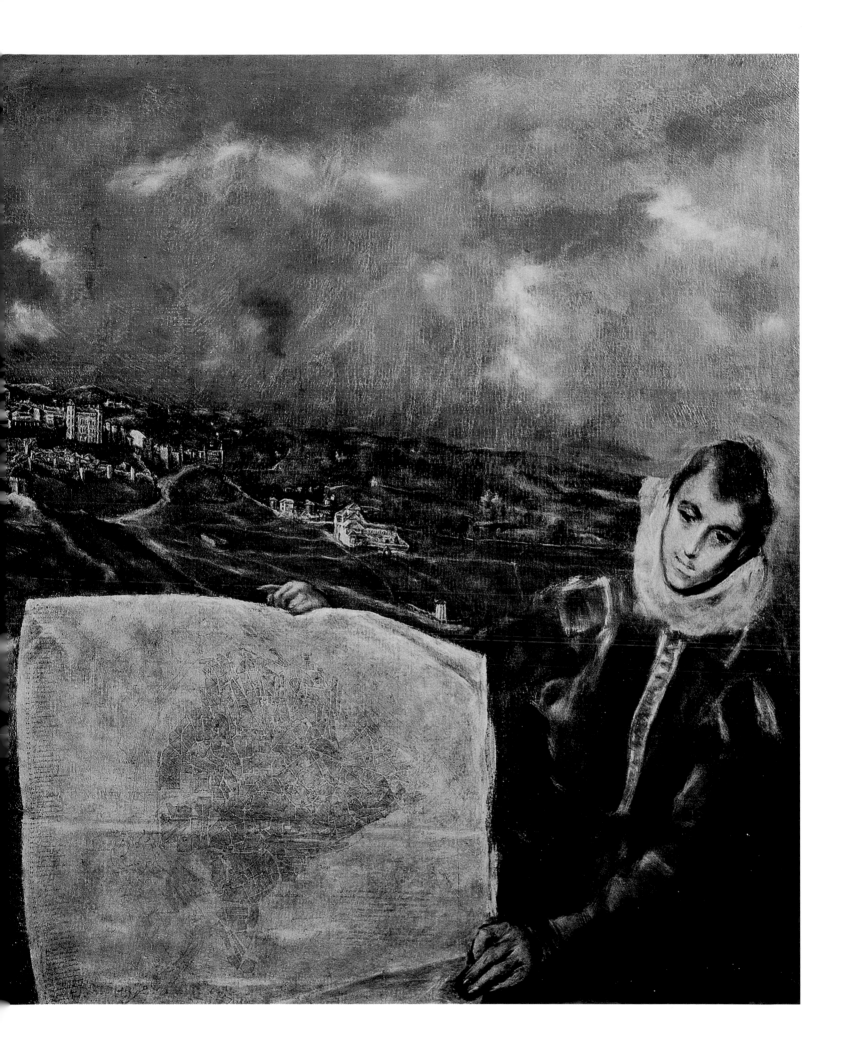

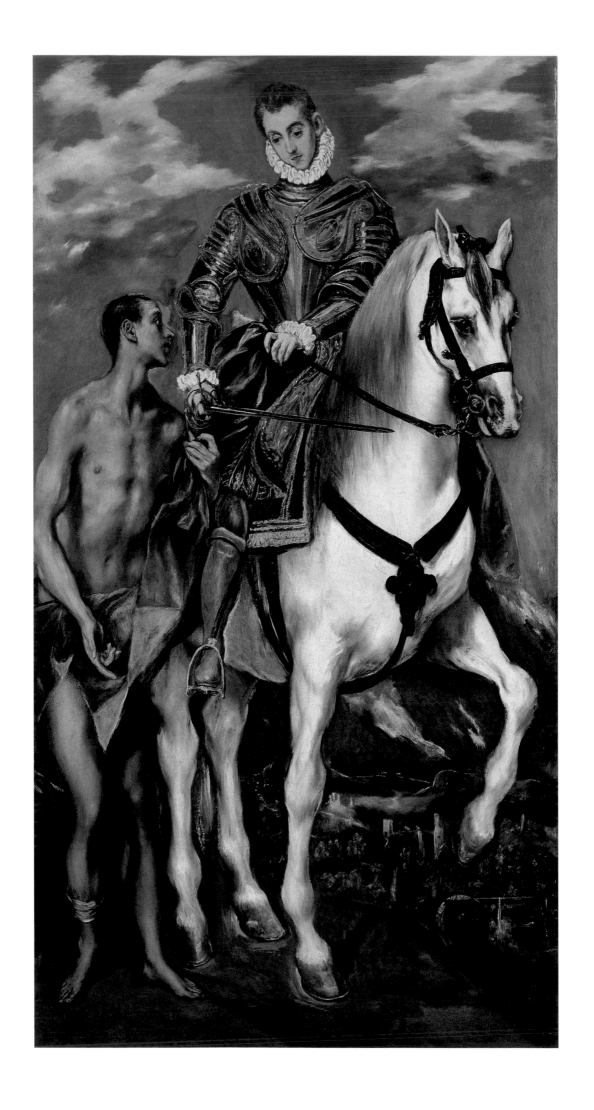

altarpiece for the Capilla de San José (ill. pp. 62 and 63). Here, to the right of St Joseph, we see a view of the city almost identical to that in *A View of Toledo*.

The commission to decorate the Capilla de San José was one of the Greek artist's most ambitious projects in Toledo after Santo Domingo el Antiguo. The contract El Greco signed on 9 November 1597 covered not only two altar paintings – the second being a *Coronation of the Virgin* above St Joseph – but, again, the design and gilding of the frame. Likewise attributed to the artist is the design for the two flanking figures of Old Testament kings, David and Solomon, these certainly not coincidentally another father-and-son pair. An inscription beneath the figure of David refers once again directly to Toledo: Jesus, it states, will reign eternally over the city like a fruit filled with seeds.

Consequently El Greco received an additional commission for the two side altars. His *St Martin and the Beggar* (ill. p. 60) hung to the left of the main altar and directly opposite the *Madonna and Child with St Martina and St Agnes* (ill. p. 64), before the two paintings were sold to an American collector in 1906.

In the persons of Castillas, Covarrubias, Paravicino y Arteaga, Cevallos and Salazar de Mendoza, we have become acquainted with some of the friends and patrons in Toledo who provided El Greco with a company quite as stimulating as he had enjoyed in Italy in the humanistic circles of Fulvio Orsini at the Farnese court. Ultimately, it was a small educated elite who appreciated the intellectual Greek principally as the right painter for their complex religious ideas, but also for their own portraits.

El Greco would probably have missed these intensive personal contacts with his patrons if he had made a career at the court of Philip II as originally planned. In Toledo, moreover, he was in demand primarily as a painter, whereas Velázquez, court artist at a later date in Madrid, had other offices to fulfil – offices which, although honourable, cost him much energy and left him hardly any time for his painting. So El Greco, the stranger from Crete, had not necessarily drawn the worse lot. The fact that he was under financial pressure throughout his life had less to do with the more unfavorable working conditions in Toledo than with his luxurious life style, which at times included musicians hired to play for him at dinner.

Yet something El Greco may have missed in Toledo was the opportunity to discuss questions of art theory with other artists. As we know from Pacheco's treatise on art, the Greek was also a writer: "He [El Greco] was a great philosopher, acute in his observations, and he wrote about painting, sculpture and architecture." Confirmation of the correctness of this statement has been found only recently, in the shape of the artist's handwritten commentaries on a Vitruvius edition by Daniele Barbaro (Venice, 1556) (ill. p. 57) and on the second edition of Giorgio Vasari's *Lives* of 1568. Indicatively El Greco did not acquire the latter book in Spain but received it from an Italian artist, his friend Federico Zuccari (ill. p. 20).

Of course El Greco's marginal notes cannot be compared to a fully-fledged book, since his ideas about art have to be pieced together by reading between the lines. He obviously felt little sympathy with the mathematical and theoretical approach that required a thorough study of proportions, and rejected the monumental classicism which, in the wake of Michelangelo, found many adherents in Spain as elsewhere. This is surely one of the reasons why he was destined to fail at the Escorial.

On the other hand, observation of nature formed an important basis for El Greco's art. He criticized Raphael for borrowing too strongly from classical

PAGES 58/59:
View and Plan of Toledo, c. 1610–1614
Oil on canvas, 132 x 228 cm (52 x 89.8 in.)
Toledo, Casa y Museo de El Greco

A particular role in the history of this painting was probably played by Pedro Salazar de Mendoza, since he was administrator of the hospital which appears on a cloud in the foreground. We also know that Mendoza devoted himself to the study of cartography and urban history.

PAGE 60:
St Martin and the Beggar, 1597–1599
Oil on canvas, 193.5 x 103 cm (76.2 x 40.6 in.)
Washington, DC, National Gallery of Art, Widener Collection

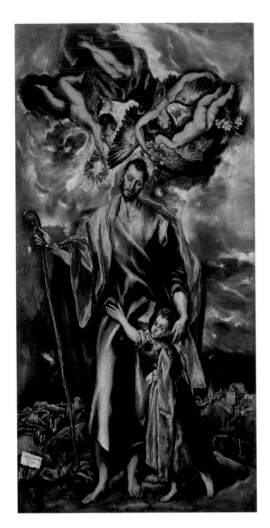

models and Michelangelo for his undifferentiated handling of colour. Titian, in contrast, whose colours especially made him an unrivalled imitator of nature, was considered by El Greco to be the most significant artist of his times: "So one could also speak about the charm of the colours of Titian, who with his ability to imitate nature and other things showed the highest genius."

Also of interest, finally, is El Greco's round rejection of Vasari's developmental model of art. He disagreed with Vasari's description of Byzantine art, from which he himself had emerged, as being coarse, and placed it on a higher level than Giotto, with whom the Florentine author associated the beginning of the Renaissance and with it modern art in general. "If he, Vasari, knew what the Greek manner he mentions is like in reality," wrote El Greco, "he would judge it differently, because I am of the opinion that, when one compares the two, that of Giotto is simple, whereas the Greek manner teaches us fruitful difficulties."

So both in practice and in theory, El Greco chose a new orientation in Spain. Of the admired artists he had so demonstratively depicted in *The Purification of the Temple* (ill. p. 22/23), namely Titian, Michelangelo, Raphael and Clovio, he remained true above all to Titian, but on the other hand he now once more confessed pride in his Greek origins.

The discovery of El Greco the theoretician in the 1990s led to a fundamental revision of his previous image. A few authors now began to view him primarily as an intellectual for whom the religious aspects of his art, previously so emphasized, were secondary. Yet this was merely to supplant one one-sided view with another, no less unbalanced, as we shall see in the next chapter.

St Joseph and the Infant Christ, 1597–1599
Oil on canvas, 109 x 56 cm (42.9 x 22.1 in.)
Toledo, Museo de Santa Cruz

A concentration on depictions of St Joseph in Spain began with an emphasis on his worship by Theresa of Avila (1515–1582; canonized in 1622), who would become Spain's national saint. El Greco's choice of an elongated figure against a background of agitated sky would subsequently be extended to the depiction of other figures.

PAGE 63:
Capilla de San José, Toledo
(overall view of interior)

At the time the commission was given, two publications on the life and virtues of St Joseph appeared in Madrid and Toledo. El Greco here created the first chapel ever consecrated to St Joseph in the entire Christian world.

LEFT:
***Madonna and Child with St Martina
and St Agnes***, 1597–1599
Oil on canvas,
193.5 x 103 cm (76.2 x 40.6 in.)
Washington, DC, National Gallery of
Art, Widener Collection

The saints are depicted with a grace
that lends them an otherworldly air.
Their stylized form reveals El Greco
to have been an admirer of Parmigian-
ino: "I am speaking of Francesco
Parmigianino," he once wrote, "who
apparently came into the world solely
in order to show, with his sketches and
designs, what is called the slenderness
and grace of figures."

RIGHT:
The Adoration of the Shepherds, c. 1610
Oil on canvas,
144.5 x 101.3 cm (56.9 x 39.9 in.)
New York, The Metropolitan Museum
of Art

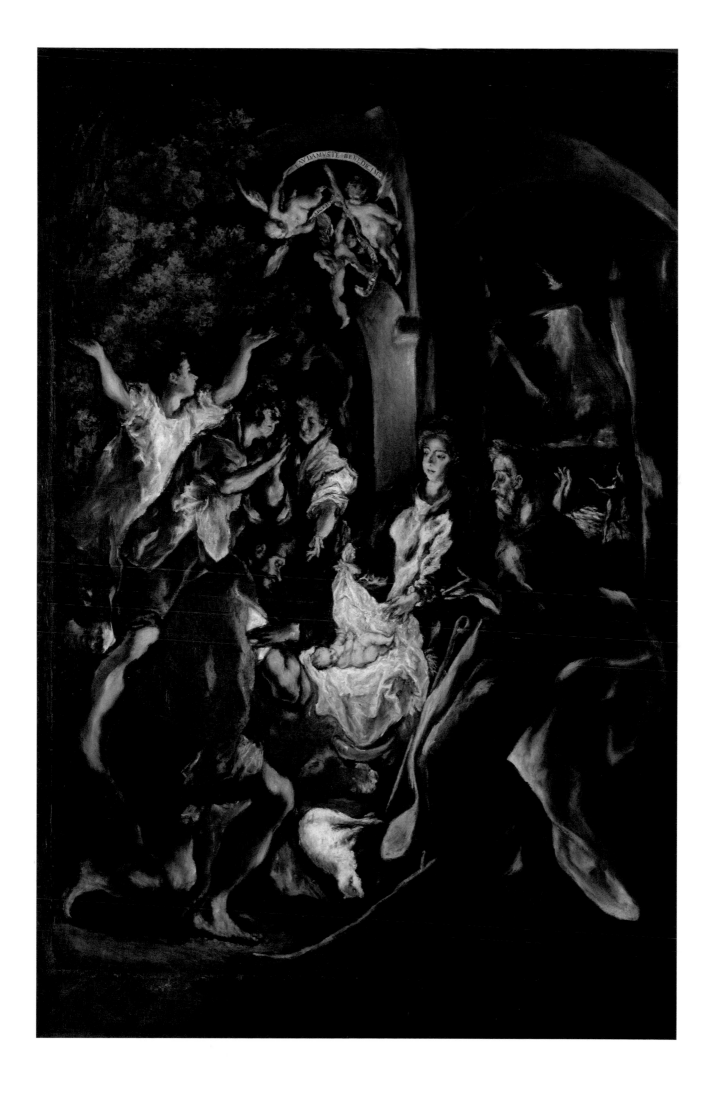

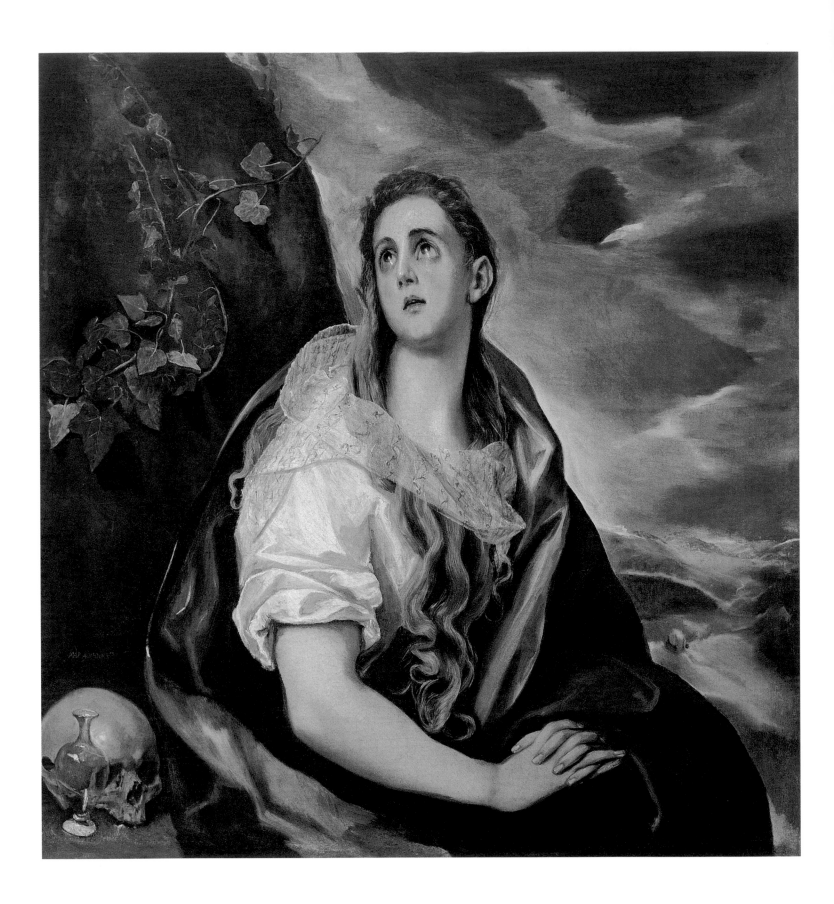

The Greek Heritage in the Conflict of Confessions

This polarization in El Greco research is the consequence of a mistaken but still widespread notion, according to which the religious art of the early modern era stood for social regression and was incompatible with the new intellectual challenges of the age.

Actually, as modern historiography has shown, the astonishing advances made in Old Europe were based not on a secularization set in motion by Luther and other reformationists but, quite the contrary, on a general return to religion which lasted until the end of the Thirty Years' War. To explain this by reference to a famous example: the achievements of a man like Galileo Galilei (1564–1642) were possible not despite the Catholic Church but only thanks to its support. And accordingly, it is El Greco's innovative contributions in the field of visual propaganda for this new confessional era that must be considered his most significant contribution to the history of European art.

Since El Greco's pictures by no means emerged in conflict with the Catholic Church, it should come as no surprise that he and his son were entrusted with the task of inspecting the parish churches in the archdiocese of Toledo for the correctness, that is orthodoxy, of their imagery. This gave their workshop an opportunity to acquire several lucrative commissions.

But in what, specifically, did El Greco's artistic contribution to a reform of Catholic imagery consist? Two fields can be distinguished. In the first place, he formulated new iconographic themes or transformed existing ones in an original way. Secondly, he experimented with an innovative visual language, for which, at an advanced age, he began to reactivate experiences from his days as a Cretan icon painter. These he blended these with the Western European modes of depiction laboriously learned during his travels into a successful individual style.

In the first field, El Greco's contrite half-length saints can be called revolutionary and groundbreaking for the art of the Baroque. El Greco isolated and monumentalized individual figures and by so doing turned them into emotional interlocutors for the faithful. Especially successful in this regard are his *Mary Magda- len in Penitence* (ill. p. 66), whom he now, in Spain, divested of the erotic traits borrowed from Titian (ill. p. 67), and his *Tears of St Peter* (ill. p. 69). Their tearful eyes directed heavenwards would later become the trademark of the Baroque painter Guido Reni, but they were anticipated by El Greco long before.

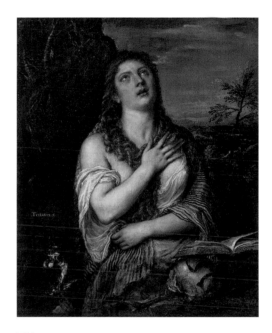

Titian
The Penitent Magdalen, c. 1561
Oil on canvas, 118 x 97 cm (46.5 x 38.2 in.)
St Petersburg, Hermitage

PAGE 66:
Mary Magdalen in Penitence, early 1580s
Oil on canvas, 108 x 101.3 cm (42.5 x 39.9 in.)
Worcester, Worcester Art Museum

Compared with the earlier Magdalen in Buda-pest (ill. p. 27), here El Greco conveys a vision of complete penitence. Sensual beauty has given way to a meditative attitude. Instead of raising one hand to her breast, Mary Magdalen folds her hands in devout prayer. The treatment of the sky approaches the Baroque in character.

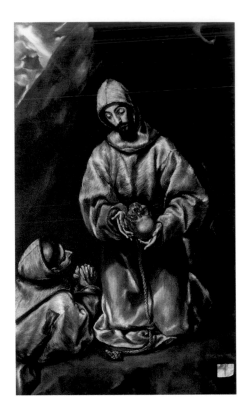

Also apparently highly popular was his *St Francis* (ill. p. 68 right), whom El Greco no longer depicted, as was previously common, at the moment of his stigmatization, that is, his miraculous reception of Christ's wounds, but in the process of musing over a skull. Shortly before the picture was done, Cardinal Caesare Baronius, supported by Pope Sixtus V, had achieved recognition of the stigmatization for the official life of the saint. And the founder of the Jesuit order, Ignatius of Loyola, had recommended the use of a skull in meditational practices in his *Spiritual Exercises.*

Even Pacheco averred that no one had captured the figure of the order's founder as described in the chronicles like El Greco, about forty versions of whose composition are still in existence even today. Two other factors probably also contributed to its extraordinary success: first, the great veneration enjoyed by St Francis in Spain – in Toledo alone, there were ten Franciscan religious institutions – and second, the recourse to modern media of dissemination. Because El Greco knew from Italy how important reproduction prints were in popularizing new visual ideas, he had an engraving done of his work (ill. p. 68 left) by his pupil Diego de Astor († c. 1650).

Another subject that enabled a direct emotional appeal to Catholic believers was El Greco's *apostolados*, or apostles series, whom he portrayed with a powerfully expressive body language. Examples are *St Luke* (ill. p. 71), from a cycle for Toledo Cathedral, and *St Bartholomew* (ill. p. 73), part of an unfinished series which is now in the El Greco Museum in Toledo.

Even though not specifically Spanish subjects, St Joseph and the Virgin Mary were particularly revered in the Hispanic world. The growing veneration of the Virgin was also a self-confident reply by the Catholic Church to Reformationist criticism after the Council of Trent. In addition to depictions of the Virgin and Child accompanied by further saints (ill. p. 72), El Greco now also addressed the subject of the *Immaculate Conception* (ill. p. 75).

Let us now turn to the second field in which El Greco set out to renew Catholic imagery and the stylistic innovations he adopted to this end. Perhaps the

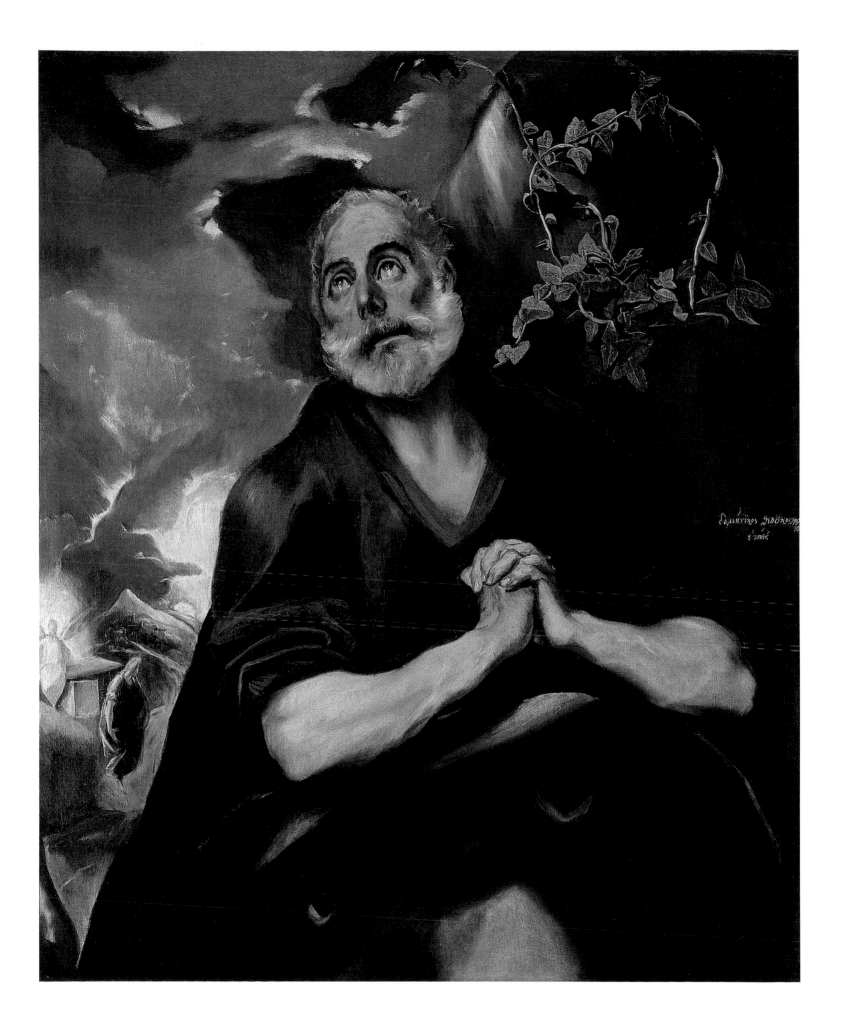

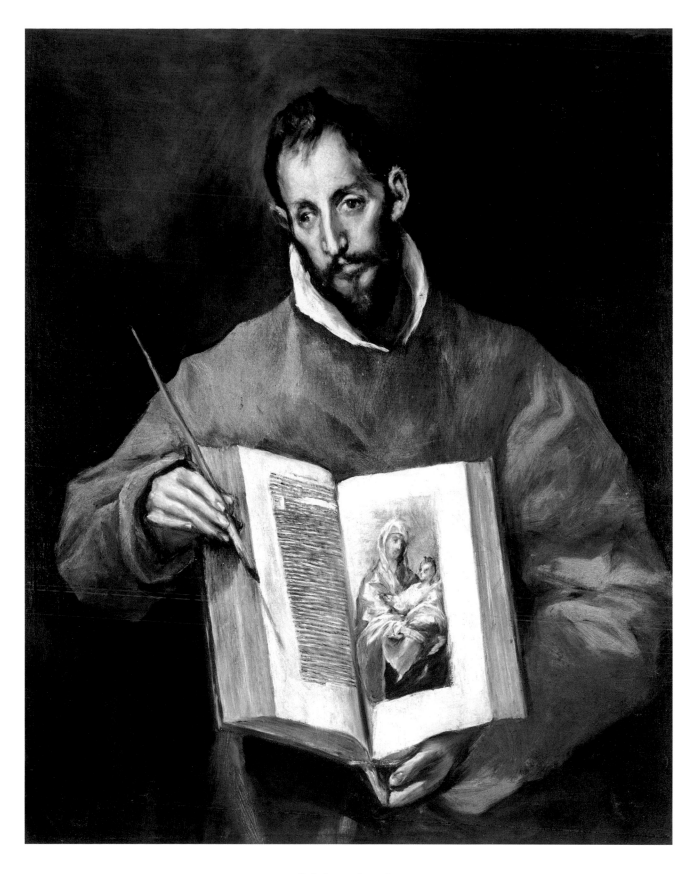

St Luke, c. 1605–1610
Oil on canvas, 98 x 72 cm (38.6 x 28.4 in.)
Toledo, Cathedral

El Greco included St Luke in several of his *apostolados*, although Luke was not actually
one of the twelve apostles. Here the artist provided the Western version of a subject
he depicted in quite different terms during his period as an icon painter.

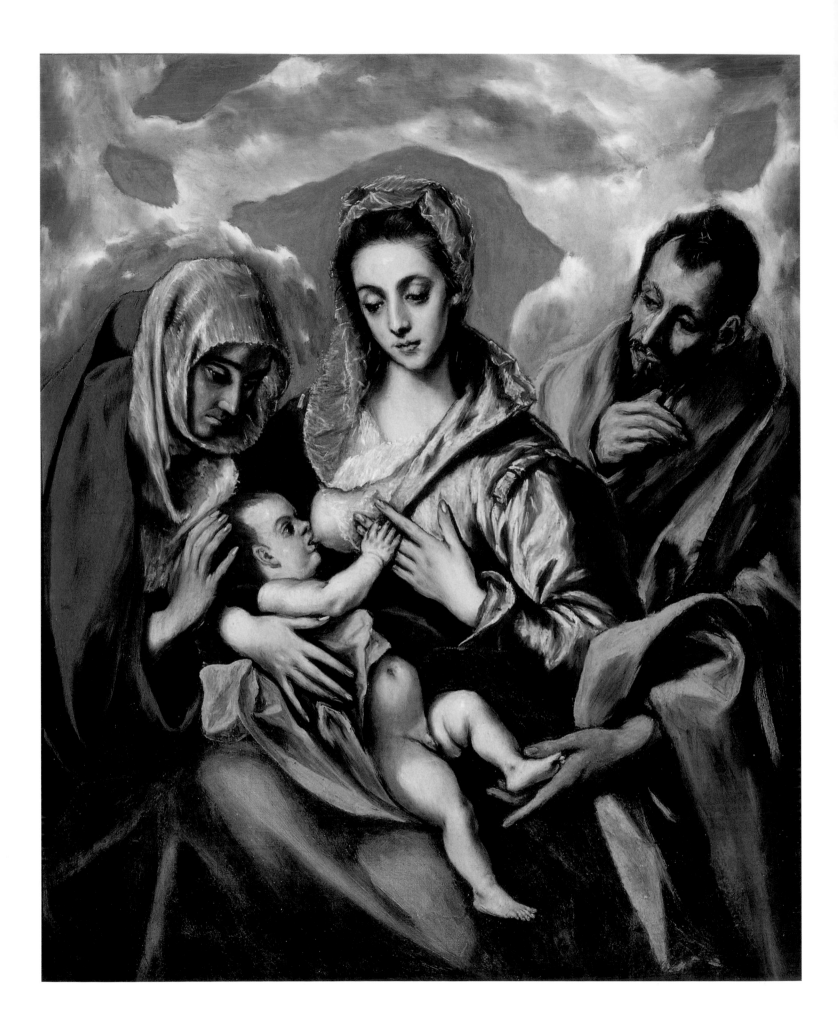

most obvious example of the recourse to Greek art mentioned above is provided by a comparison between *The Burial of the Count of Orgaz* (ill. p. 50) and an early treatment of *The Dormition of the Virgin* (ill. p. 6). As we immediately see, the artist has not only borrowed features such as the visualization of the soul. The entire composition and the atmosphere of the picture painted in Spain bear affinities with the spirit of icon painting.

But there are also differences. If we compare a late version of *The Purification of the Temple* from 1610–1614 with El Greco's early treatment of the same subject (ill. pp. 22/23), it is apparent that the realism of the 1570s canvas has now become more abstract and the figures more animated. The dramatic quality of the lighting has been heightened to such a degree that some have spoken, not without justification, of an "expressionist" style with regard to the works of this period.

These new "expressionist" stylistic traits are also found in the paintings of a retable El Greco created for the Augustinian college of Nuestra Señora de la Encarnación in Madrid between 1596 and 1600. The patroness of the college, the lady-in-waiting Doña María de Córdoba y Aragón, had died back in 1593, implying that the commission likely came from her executor. The retable, like many other works in possession of the Church, was disassembled into its component parts during the French occupation of Spain. All we know from the surviving written sources is that El Greco supplied a total of seven paintings. Five of them are now generally identified with works in the Prado; one is said to be in the Romanian National Museum in Bucharest; and the seventh is considered lost.

The two works from Madrid illustrated here, *The Annunciation* (ill. p. 74) and *The Pentecost* (ill. p. 75 right), are especially good examples of the daring palette that characterizes the entire series. In *The Annunciation*, the main painting of the retable, the artist seems even to have gone so far as to abandon nearly every reference to the objective world.

The best impression of the visionary heights in El Greco's late style, finally, is conveyed by a fragment with the title *The Vision of St John* (ill. p. 88), which, however, might more aptly be described as a vision of St John the Evangelist. This is one of three altar paintings commissioned by Pedro Salazar de Mendoza in 1608 for the church of the Hospital Tavera and which the artist was unable to complete. Compared to other treatments of the subject, such as that by Albrecht Dürer, one is immediately struck by the way El Greco integrates the saint in the picture, thus placing the accent not on a depiction of the actual event, the opening of the seal, but on his vision of it. The dematerialization of form achieved in this and other works would fascinate artists of Classical Modernism from Pablo Picasso to Jackson Pollock, as we shall see below.

St Bartholomew, c. 1610–1614
Oil on canvas, 97 x 77 cm (38.2 x 30.3 in.)
Toledo, Casa y Museo de El Greco

St Bartholomew was flayed alive, so a knife came to serve as his attribute. This brutal martyrdom made depictions of him very popular in the 17th century. El Greco, in contrast, replaced St Bartholomew in his Apostles Series by St Luke, the present painting being the single exception.

PAGE 72:
The Holy Family with St Anne, c. 1590–1595
Oil on canvas, 127 x 106 cm (50 x 41.7 in.)
Toledo, Hospital Tavera

As an X-ray of this painting has revealed, El Greco departed farther and farther from natural appearances in his Toledo period. Mary's face, for instance, originally plump and rounded, was later given a more delicate and graceful appearance.

PAGE 74:
The Annunciation, c. 1596–1600
Oil on canvas, 315 x 174 cm (124 x 68.5 in.)
Madrid, Museo Nacional del Prado
(formerly College of Doña María de Aragón)

Although the sewing basket, part of the classical inconography of the Annunciation, appears almost tangibly real, it is accompanied by the unusual feature of a bush in flames, an allusion to the burning bush of Moses as a prefiguration of the redemption.

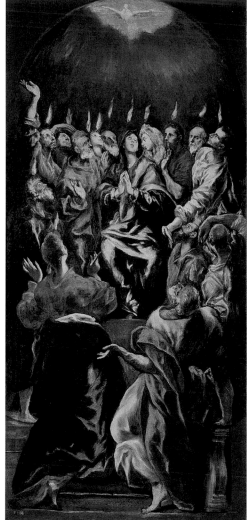

The Pentecost, c. 1596–1600
Oil on canvas, 275 x 127 cm (108.3 x 50 in.)
Madrid, Museo Nacional del Prado
(formerly College of Doña María de Aragón)

The commission for the retable for Doña María de Aragón in Madrid was the most significant El Greco ever received, and brought him the enormous sum of nearly 6,000 ducats. The depiction of the Pentecost was probably located in the upper register, to the right of the Crucifixion.

The Immaculate Conception, 1607–1613
Oil on canvas, 347 x 174 cm (136.6 x 68.5 in.)
Toledo, Museo de Santa Cruz

The dogma of Mary's immaculate conception was a point of contention between Franciscans and Dominicans in Italy, but in 17th-century Spain, with the king's support, it became the focus of a great popular movement. Visual imagery played an important role in efforts to disseminate the cult.

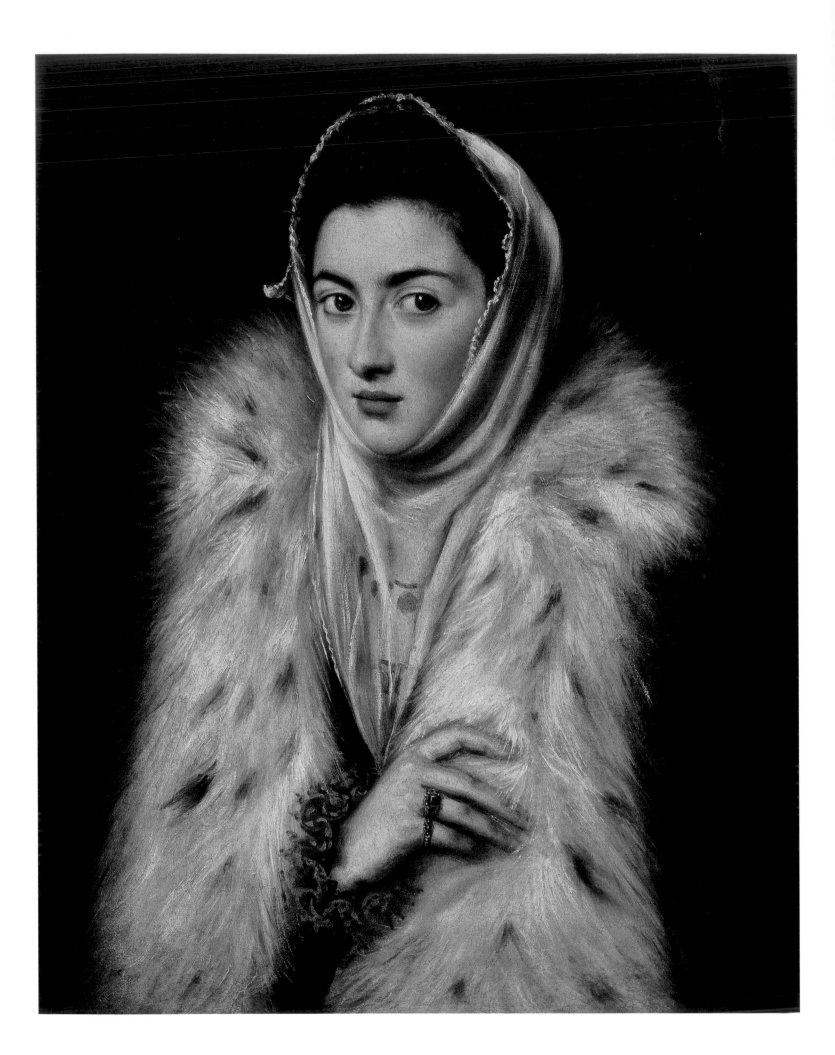

Posthumous Fame in Spain

In his old age El Greco recalled his artistic beginnings on Crete, his training in icon painting. This did not make his integration in the Spanish, or more precisely, the Toledan art scene any easier.

Some art historians have maintained that El Greco's late style was the result of an eye ailment. That it was not failing vision but conscious volition that led to these works is proven by *View and Plan of Toledo* (ill. pp. 58/59), an extremely detailed painting from the artist's final years. Moreover, it possibly also contains a reference to his early work, for, as we recall, it was to a cartographer on Crete that El Greco wrote his first letters from Venice. Might the artist, too, have drawn maps during his early years?

After 1600 his son, Jorge Manuel Theotokopoulos (1578–1631), formed the key bridgehead to Spanish reality. His portrait as an eight-year-old in *The Burial of the Count of Orgaz* (ill. p. 50) was not to remain the only one; a second was painted in 1600–1605 (ill. p. 79). El Greco had himself trained his son in painting, sculpture and architecture and soon entrusted him with tasks in his workshop. His name first appears in a document of 1597, in which he and another assistant, the aforementioned Francisco Prevoste, pledged themselves to finish the work of the master should he unexpectedly die. From 1603 onwards Jorge Manuel's name appears more regularly in the workshop records, and from 1607 he seems to have held a dominant position there.

From 1596 onwards, El Greco's workshop always had a great deal to do. The workload reached a peak in the years 1600 to 1608. Yet after 1607, the family was plunged into a true financial crisis by a quarrel over the pictorial programme for a hospital in Illescas. For unexplained reasons, El Greco had accepted unfavourable conditions in the contract. Since his clients were even reluctant to remunerate him for expenses, he went to court, resulting in further expenses.

Jorge Manuel did not develop much individual profile as a painter. Yet as an architect, at least in Toledo, he carved out a successful career. After his father's death he ran the workshop and produced paintings that relied entirely on his father's example. In recent years these works have increasingly become the focus of research, and attempts have been made to define the precise extent of the contributions by father and son. Three examples may shed light on the problems involved in this undertaking.

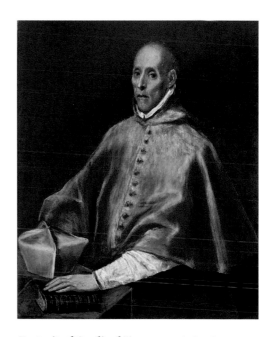

Portrait of Cardinal Tavera, c. 1608–1614
Oil on canvas, 103 x 83 cm (40.55 x 32.7 in.)
Toledo, Hospital Tavera

PAGE 76:
Sofonisba Anguissola or El Greco (?)
Lady in a Fur Wrap, late 1570s (?)
Oil on canvas, 62.5 x 58.9 cm (24.6 x 23.2 in.)
Glasgow Museums, Kelvingrove Art Gallery and Museum, The Stirling-Maxwell Collection, Pollock House

Two features speak for an attribution of this work to Sofonisba Anguissola: the suggested identification of the sitter as the Infanta Catalina Micaela, daughter of Philip II, and the smooth porcelain beauty of the portrait.

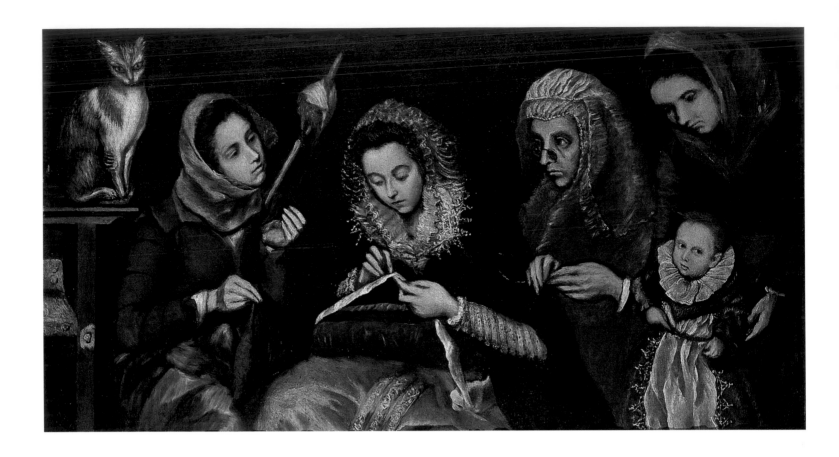

Jorge Manuel Theotokopoulos
The Family of El Greco, c. 1605 (?)
Oil on canvas, 97 x 51.5 cm (38.2 x 20.3 in.)
Madrid, Real Academia de Bellas Artes
de San Fernando

PAGE 79:
Jorge Manuel Theotokopoulos, 1600–1605
Oil on canvas, 74 x 51.5 cm (29.1 x 20.3 in.)
Seville, Museo de Bellas Artes

Here El Greco depicts his son as an artist and at
the same time as a member of the upper class.
In the eyes of his Spanish contemporaries, an
artist's palette and a ruff collar were still
incompatible. By 1900, in contrast, artists were
attending academies and the most successful
among them enjoyed high social status.

In collaboration with his father, in 1603–1607 Jorge Manuel executed an exten-
sive programme of pictures for the Hospital de la Caridad in Illescas: a *Madonna
of Charity*, a *Coronation of the Virgin*, an *Annunciation*, and a *Nativity*. Under
a separate contract a further picture was made, of *St Ildefonso* (ill. p. 82), who
was particularly important for Toledo. The clients were not satisfied, especially
with the depiction of *The Madonna of Charity* (ill. p. 80). For under the cloak of
the Madonna of the Protective Mantle, El Greco collected a number of persons
in contemporary garb who seemed hardly to require the protection of the hos-
pital for the poor. The men wear the aristocratic ruff and one of them is thought
to be, once again, a portrait of the artist's son. The extent of Jorge Manuel's
contribution to this commission remains a matter of conjecture to this day, yet
the presence of his portrait would suggest that it was greater than in previous
cases.

The painting undoubtedly missed the mark, and it is understandable that
the clients – after El Greco's death, to do them justice – had the ruffs painted
over, thus transforming the gentlemen into beggars (ill. p. 81). Poverty, a national
problem in Spain that even sparked the emergence of a special literary genre,
the picaresque novel, remained foreign to El Greco, like so many other aspects
of the Spanish mentality. It is also surprising that he joined none of the *con-
fradías* or *hermandades*, the religious brotherhoods which played such a signifi-
cant role in the religious and social life of Spanish cities.

Likewise by father and son was a painting made for a side altar of the Hos-
pital Tavera, and in the course of whose execution El Greco died. At the end of
the 19th century it was cut into two sections, which are now in different collect-
ions. The *Annunciation* and a *Gloriole* are in Madrid. *The Choir of Angels*, the
upper section, is now in Athens. The contribution of Jorge Manuel to the *An-
nunciation* is extremely controversial. Probably El Greco's son found the design
finished and limited himself to absolutely necessary additions. In the original

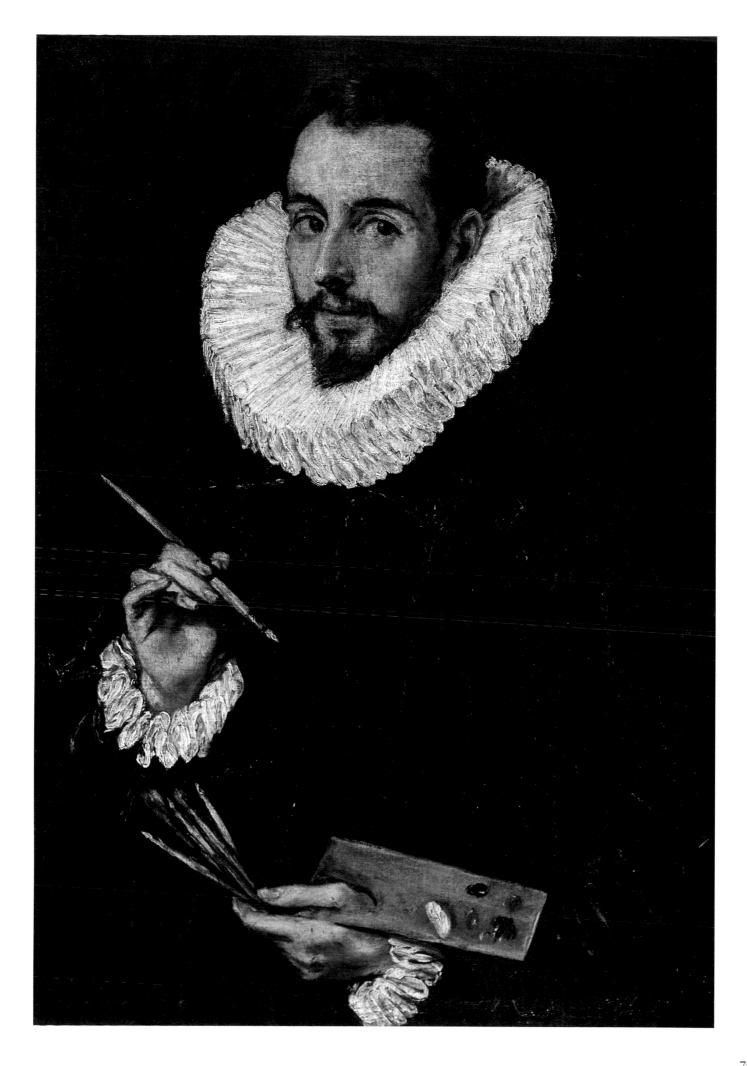

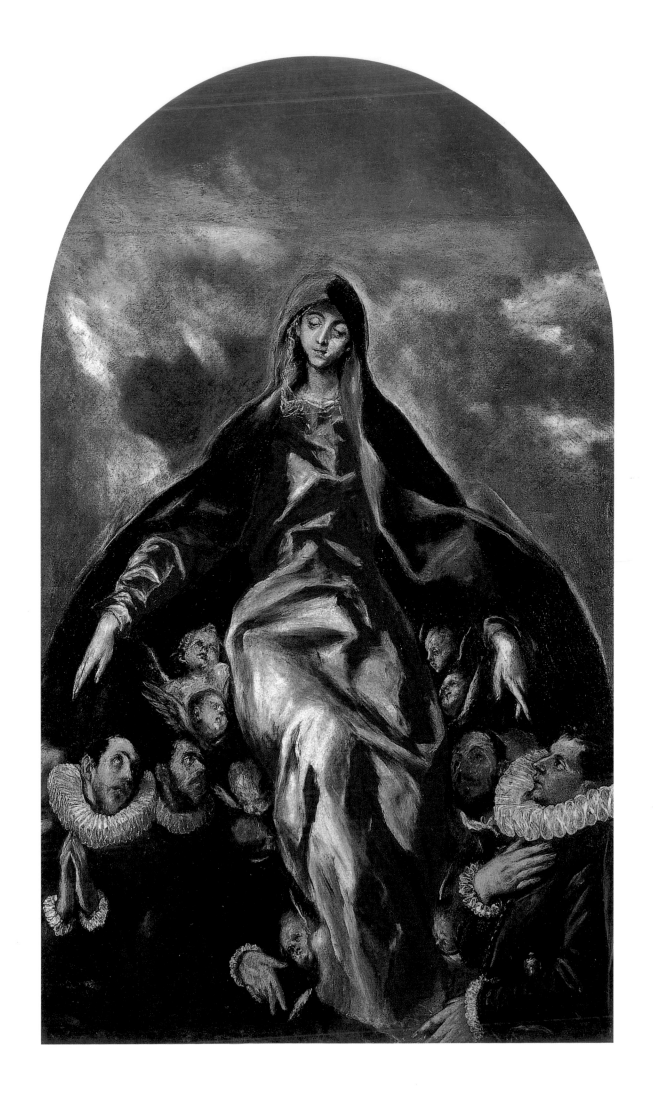

design by El Greco's own hand, which was reconstructed with the aid of an X-ray, the figures were to be located at a higher point in the composition. Mary turns her face toward heaven and folds her hands in prayer. In the upper section the finished character of the design is even more obvious, so that Jorge Manuel probably did not supplement it at all.

Occasionally attributed to El Greco, but now generally ascribed to Jorge Manuel, is the so-called *Family of El Greco* from around 1605 (ill. p. 78). The painting evinces a number of irregularities of execution that suggest the involvement of different hands. The fact that the painting does not appear in the inventories of Jorge Manuel's property would seem to speak against its association with the El Greco family.

Many other artists passed through El Greco's large workshop in Toledo besides his son and Prevoste, and the printmaker Diego de Astor mentioned earlier. Especially significant for Spanish art history was Luis Tristán (c. 1585–1624), who studied with El Greco from 1603 to 1606 and whom Palomino expressly mentions as one of two El Greco pupils. Tristán's *Crucifix* in the Museo de Santa Cruz might initially recall El Greco's approach, as in *The Crucifixion with Two Donors* (ill. p. 43). Yet the only shared features are the elongated figures and the face raised to heaven. A specially marked difference is seen in the handling of light and shade. Tristán probably had access to Florentine painting by way of Caravaggio and employed his chiaroscuro at a relatively early date for Spain. The Upper Italian artist, so crucial for Baroque painting, died in 1610 and thus prior to El Greco, yet still remained entirely without importance for the Greek's art. Caravaggio's conception of naturalism was quite different from El Greco's.

When we come to problematic attributions to El Greco, *Lady in a Fur Wrap* (ill. p. 76) provides perhaps the most interesting example. Recent research dates the work to the 1570s. Yet there are weighty arguments for considering it not a work of El Greco's at all but from the hand of a female artist, Sofonisba Anguissola (1535/40–1625). Perhaps the most famous copy of the portrait was made in the 19th century by Paul Cézanne. He was still certain that it was by El Greco. Yet Cézanne did not know the original and based his copy on a reproduction.

El Greco never lost touch with his Greek origins. He enjoyed an especially close friendship with the Hellenist Antonio de Covarrubias (ill. p. 52) and maintained relationships with his countrymen until his death: two Greeks witnessed his last will and testament and his brother, Manoussos, spent the final years of his life in El Greco's Toledo residence.

One of the artist's most unusual pictures, the depiction of a *Laocoön* (ill. pp. 86/87) with a view of Toledo in the background which he executed during the years 1610–1614, might be viewed as a summing-up of El Greco's lengthy journey across the Mediterranean region. There is a namely legend according to which Toledo was founded by two strangers from the eastern Mediterranean, the Trojans Telemon and Brutus. This legend must certainly have held a great appeal for El Greco.

The picture seems never to have left the artist's studio, where it and two further versions of the same subject were listed as being present in 1614. El Greco's sole mythological composition, the painting stands in a rich tradition, which rests in equal measure on Virgil's *Aeneid* and the discovery of the renowned Hellenistic sculpture of Laocoön in Rome in 1506. The figures at the right edge were left unfinished. Perhaps only a group of two was originally intended, since the head behind the foremost figure, not revealed until a restoration in the 1950s, looks like a first version of that figure.

The Madonna of Charity (detail), 1603–1605
Oil on canvas, 184 x 124 cm (72.4 x 48.8 in.)
Illescas, Hospital de la Caridad
(before restoration)

Although El Greco's visual ideas were frequently criticized, his pictures were not normally corrected. Here we have the most spectacular exception to the rule: right after his death the clients had the figures' ruffs painted over. No wonder this incident in Illescas found its way into Palomino's treatise on art.

PAGE 80:
The Madonna of Charity, 1603–1605
Oil on canvas, 184 x 124 cm (72.4 x 48.8 in.)
Illescas, Hospital de la Caridad
(after restoration)

The mantle of the Madonna of Charity seems to protect in particular those who were already better-off, as indicated by the ruffs, which were introduced into Spain by Philip III in about 1600. The figures depicted are thought to include a portrait of El Greco's son, Jorge Manuel.

Apart from unanswered questions regarding his iconography, what else did El Greco bequeath to the country he settled in, seeing that not even his own son was capable of continuing his individual style? Palomino credited him with being the first artist in Spain to have refused to pay the artisans' tax, the *alcabala*, and thus to have paved the way for the rise of painting into the sphere of the Fine Arts. This is not the whole truth, since El Greco conducted his court cases solely in his own interest, to obtain adequate remuneration for his pictorial inventions; the discussion concerning the *alcabala*, so crucial for Spanish artists, did not come until later. Nevertheless, Palomino's evaluation is not incorrect. The activities in Spain of the foreigner from Crete who had matured into an artist in Italy, where Federico Zuccari made more of a career as an intellectual than as a painter (ill. p. 20), contributed materially to the nascent emancipation of the visual arts from the handicrafts. One need only view the portrait of his son, posing proudly in his ruff (ill. p. 79), to recognize the new social standards he claimed. And as the visit of Pacheco, the most significant art theoretician in Spain, to El Greco shortly before his death surely implies, his voice found a hearing among his Spanish contemporaries during his lifetime.

The last word is due to one of these intellectual friends of the artist, because they furthered his advancement in the face of the many obstacles placed in his path. In the sonnet to El Greco which he composed in 1614, Father Hortensio Félix Paravicino wrote the following lines: "Crete gave him life and art, Toledo a better home, where through death he attained to eternal life."

PAGE 82:
St Ildefonso, 1603–1605
Oil on canvas, 187 x 102 cm (73.6 x 40.2 in.)
Illescas, Hospital de la Caridad

In his depiction of St Ildefonso, too, El Greco anticipated a Baroque motif, that of the learned churchman. As if receiving inspiration, the saint is seated at a desk covered with an array of utensils that is unusually detailed for the artist.

PAGE 84:
St Jerome as Cardinal, c. 1600–1614
Oil on canvas, 108 x 89 cm (42.5 x 35 in.)
New York, The Metropolitan Museum of Art,
Robert Lehman Collection

PAGE 85:
St John the Evangelist, 1595–1604
Oil on canvas, 90 x 77 cm (35.4 x 30.3 in.)
Madrid, Museo Nacional del Prado

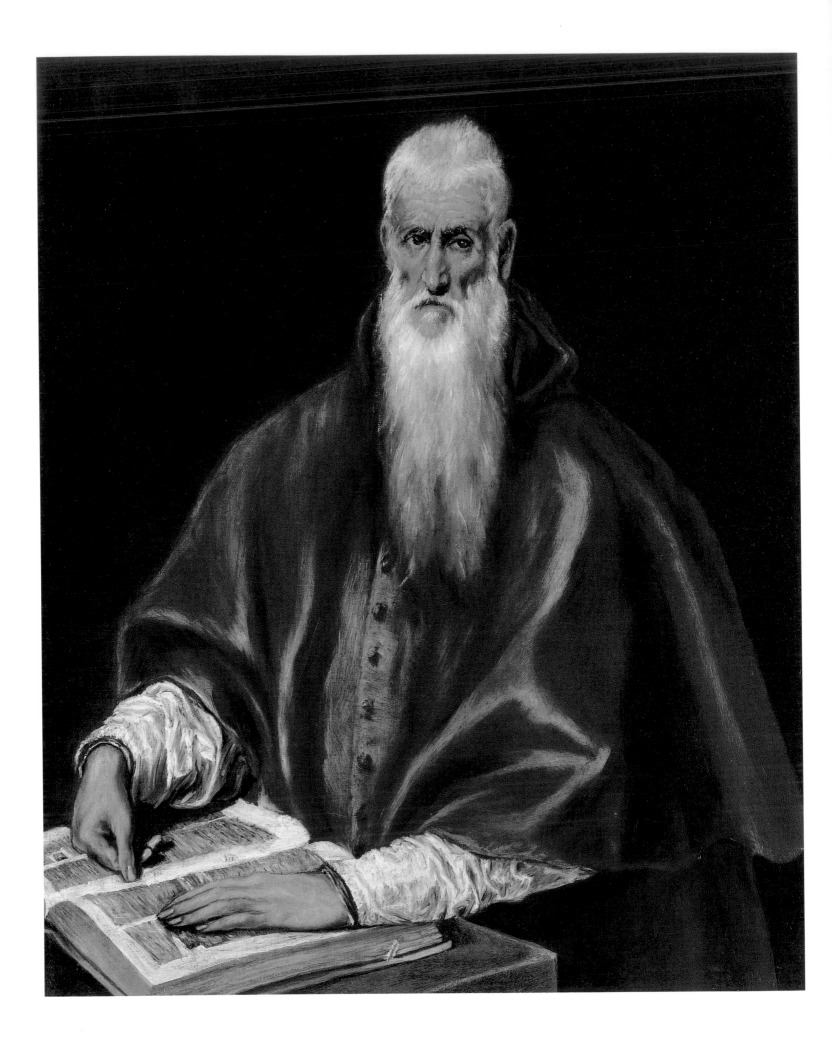

85

Laocoön, 1610–1614
Oil on canvas, 137.5 x 172.5 cm (54.1 x 67.9 in.)
Washington, DC, National Gallery of Art

If the foremost figure is actually holding an apple, as many assume, this may allude to Adam and Eve or to Helen and Paris, whose love affair triggered the Trojan War.

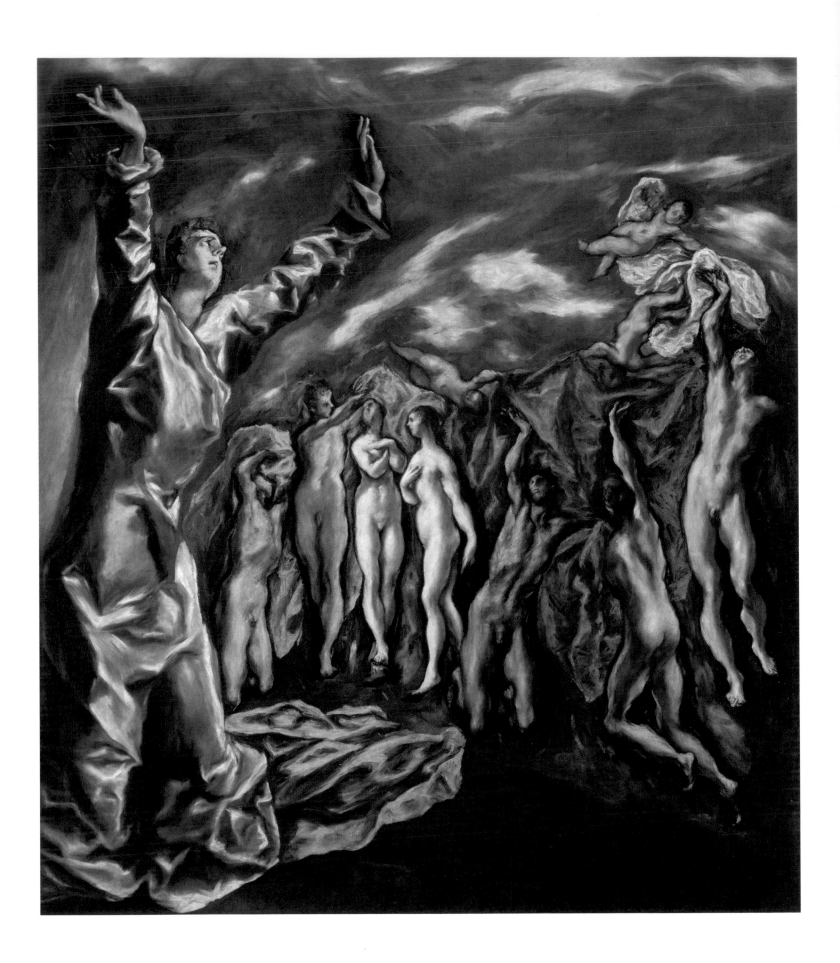

The first "Homeless Man of Art"
and the Avant-Garde

Roman Baroque art knew little of El Greco, and Spanish classicism around 1800 considered his works affected and exaggerated. Even Palomino could remark critically about his late work: "But when he saw that his paintings were confused with those of Titian, he attempted to change his style with such extravagance that he made his painting inferior and ridiculous both in the distortions of drawing and the insipidness of colour." But it was especially the neoclassicists of the Spanish Enlightenment in the orbit of Goya who had very little good to say about El Greco.

It was intellectuals – cartographers, fellow artists, clergymen, humanists etc. – rather than aristocrats, royalty and their courts who furthered El Greco, and it was authors, art critics and an international artistic avant-garde around 1900, not art historians, who paved the way for his rediscovery. A first significant phase in this gradual and perhaps only now completed process was the opening of the "Spanish Gallery" of Citizen-King Louis Philippe of France at the Louvre in 1838, at which all of nine El Greco paintings were displayed. Yet the decisive breakthrough did not come until around 1900, when Spanish intellectuals and artists in search of their intrinsic identity discovered, of all people, the foreigner from Crete as a painter especially typical of Spain. Their spokesman was Ignacio Zuloaga (1870–1945), a Basque artist whose Spanish themes had gained him fame far beyond the borders of the Iberian Peninsula. As early as 1887 he copied works by El Greco in the Prado and later borrowed a few of his motifs for his own paintings. In 1905 Zuloaga acquired *The Vision of St John* (ill. p. 88), which at that time was interpreted as a representation of heavenly and earthly love. He chose it as the background for his painting *Mis amigos*, which portrays several literati of the generation of 1898 who played such a crucial role in Spain. Finally, Zuloaga was instrumental as an advocate and mediator for El Greco beyond his own circle of close friends.

At Zuloaga's suggestion, Santiago Rusiñol, one of the leading artists of Catalan *Modernisme*, or Art Nouveau, purchased two El Grecos in Paris as early as 1893 and in a symbolic act took them back home with him to Spain and hung them in his house in Sitges. Also through Zuloaga, whose art he admired, Rainer Maria Rilke heard about El Greco and travelled to Toledo in 1912. The distinguished German art critic Julius Meier-Graefe had preceded Rilke to Spain. Meier-Graefe's *Spanische Reise* (*Spanish Journey*) of 1910 was a single paean to

Pablo Picasso
Les Demoiselles d'Avignon, 1907
Oil on canvas, 243.9 x 233.7 cm (96 x 92 in.)
New York, The Museum of Modern Art

PAGE 88:
The Vision of St John, 1608–1614
Oil on canvas, 222.3 x 193 cm (87.5 x 76 in.)
New York, The Metropolitan Museum of Art, Rogers Fund

The upper section of this painting, the actual vision of the Apocalypse, was never finished by El Greco. In the course of a "restoration" about the year 1880, the picture was trimmed by at least 175 cm (68.9 in.). As a result, the dramatic gesture of John the Evangelist points nowhere, a non sequitur that nevertheless has apparently intrigued modern viewers especially.

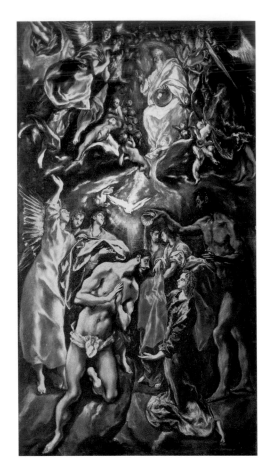

The Baptism of Christ, 1608–1614
Oil on canvas, 330 x 211 cm (129.9 x 83.1 in.)
Toledo, Hospital Tavera

El Greco and went hand in hand with a sea change in art criticism, away from Impressionism and towards Expressionism. So it was no wonder that modern artists in Germany combined the Cologne "Sonderbund" exhibition of 1912, a key avant-garde event, with an homage to El Greco.

Pablo Picasso was an eye-witness to El Greco fever in Spain, both in Madrid and Barcelona. So it should come as no surprise that in his first significant phase, the Blue Period, he alluded again and again to El Greco. Picasso's *Burial of Casagemas* would be unthinkable without *The Burial of the Count of Orgaz* (ill. p. 50). How strongly he identified with El Greco at that time can be seen from the title of a drawing, *Yo El Greco*, or *I, El Greco*. Zuloaga served as a mediator in Picasso's case as well. When, at the end of his Pink Period, Picasso painted the scandalous *Demoiselles d'Avignon* (ill. p. 89), he took up a few motifs from *The Vision of St John* (ill. p. 88), described by its owner, Zuloaga, as possessing a "visionary power" that made it a "precursor of modernism". Even as late as the 1950s, when Picasso had apparently broken with every tradition in Western art, he embarked to the surprise of his audience on a new phase of art about art, in which he once again returned to El Greco.

Picasso shared in common with El Greco the role of a stranger between cultures and a link with the Mediterranean. After the end of the Spanish Civil War in 1940, his application for French citizenship was rejected, and after 1945 he fled from enmities in Paris to the Côte d'Azur, a coast that reminded him of his birthplace, Malaga, and of Barcelona.

How similar El Greco was to Picasso in other respects as well, has come to light thanks to his discovery as a theoretician. In this regard the Greek proves himself to have been an eloquent champion of contemporaneous art vis-à-vis the art of antiquity, without ever have entirely rejected the latter.

According to Meier-Graefe's characterization, El Greco derived his stamina from his very lack of a homeland. He created his own identity by turning his apparent deficits, those of an icon painter in the Byzantine tradition, into strengths in the context of Western art, and shaping from a hybrid mixture of different cultures an individual and original style – if one that would not find its true public until 400 years later.

PAGE 91:
The Visitation, early 1610s
Oil on canvas, oval, 96 x 72.4 cm (37.8 x 28.5 in.)
Washington, DC, Dumbarton Oaks,
House Collection

El Greco 1541–1614
Chronology

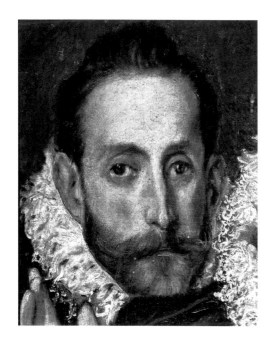

1541 Domenikos Theotokopoulos, known as El Greco, is born in Candia (now Heraklion), Crete. At this period the city is in the possession of the Venetian Republic. El Greco's father, Georgios Theotokopoulos, is a government tax collector and active in trade, as his brother, Manoussos, is likewise to be.

1563 El Greco is mentioned in a document as a master of icon painting.

1566 *A Passion of Christ* from El Greco's hand is valued at the high price of 70 ducats by Georgios Klontzas, a well-known Cretan icon painter.

1567 El Greco paints a *Dormition of the Virgin* for a church in Ermoupolis, on the island of Syros. This is the first surviving work bearing his signature.

1568 A letter of 18 August confirms El Greco's presence in Venice. He sends drawings to the Cretan cartographer Giorgio Sideris.

1570 Giulio Clovio, a Croatian painter of miniatures, recommends a "fellow from Candia, a disciple of Titian" to his patron Alessandro Farnese in Rome. Possibly as thanks for this recommendation, El Greco paints a portrait of his friend.

At the Palazzo Farnese he becomes acquainted with Fulvio Orsini, a well-known humanist and librarian, whose collection would later include seven El Greco paintings. Possibly through Pedro Chacón, a close friend of Orsini's, the artist also meets the Spanish churchman Luis de Castilla, who would become one of his closest friends.

1572 On 18 September, under the name "Dominico Greco," El Greco joins the St Luke's Guild in Rome and opens his own workshop there.

He receives support from the Italian painter Francesco Prevoste, who will later accompany him to Spain. According to a report by Mancini, El Greco extends an offer to Pope Pius V to paint over Michelangelo's *Last Judgement* in the Sistine Chapel, which has drawn considerable criticism. This leads to a negative reaction on the part of Roman artists which forces him to leave the city.

1576 Although Mancini's report is considered unreliable, no other explanation for El Greco's presence in Spain by this time has been found. At any rate, we do know that he receives several commissions: an *Adoration of the Name of Jesus* for King Philip II, and, by arrangement of Diego de Castilla, his friend Luis's father, a *Disrobing of Christ* for the cathedral in Toledo and a complete retable (including designs for architecture and sculpture) for Santo Domingo el Antiguo. In the former case a dispute arises over the

TOP LEFT:
Possible self-portrait of El Greco. Detail from *The Burial of the Count of Orgaz* (ill. p. 50).

PAGE 93:
Frederick de Wit
Map of Crete (detail), c. 1680
Coloured copperplate engraving,
46.5 x 55.5 cm (18.3 x 21.9 in.)
London, O'Shea Gallery

92

price and execution of the composition, something that is to accompany almost all of El Greco's large commissions from this point onward.

1578 With his partner Jerónima de las Cuevas, El Greco has a son, whom they name Jorge Manuel after the artist's father and brother.

1580–1582 As a trial painting for the Escorial church, El Greco executes *The Martyrdom of St Maurice*. The work is amply remunerated and not subjected to corrections. Still, Philip II offers no further commissions to the artist since, according to the chronicler of the Escorial, he considers the painting unsuited to its intended site.

1585 On 10 September El Greco rents three suites of rooms in the palace of the Marqués de Villena, in the former Jewish quarter of Toledo. He will live here with his son until 1590, and again from 1604 onwards.

1586 On 18 March El Greco is commissioned by the priest of his own parish to paint *The Burial of the Count of Orgaz*.

1589 A document mentions El Greco as a "vecino", or inhabitant, of Toledo.

1596 From this year until 1600, El Greco devotes himself to a retable for the Augustine College of Doña María de Aragón in Madrid, and is paid 6,000 ducats, the largest sum he ever receives for a single commission.

1597 On 9 November El Greco is entrusted with the decoration of the Capilla de San José (Chapel of St Joseph), a further large project in Toledo.

1600 After his failed attempts at the Escorial, El Greco tries a second time to gain a significant patron with his portrait of the Grand Inquisitor Fernando Niño de Guevara.

1603 The artist's son Jorge Manuel, who is recorded to have worked for his father since 1597, begins to be mentioned more frequently in workshop documents. He will assume a leading position in 1607, likely as a replacement for the deceased Prevoste.

1603–1607 Disputes over the pictorial programme for the Hospital de la

Caridad in Illescas plunge El Greco into serious financial difficulties. From 1603 to 1606 Luis Tristán, who would become the foremost artist in Toledo after El Greco's death, is employed in his workshop.

1608 Pedro Salazar de Mendoza commissions El Greco to execute three altar paintings for the Hospital Tavera. The project remains uncompleted due to the artist's death. *The Vision of St John* will later be interpreted as an allegory of earthly and heavenly love. This misunderstanding facilitates a fruitful reception of the work, which extends to Picasso's *Les Demoiselles d'Avignon*.

1611 Francisco Pacheco of Seville, Velázquez's teacher and father-in-law, visits El Greco in Toledo. He executes a portrait of the artist and devotes a biography to him in his planned book on famous painters (both of which have unfortunately since been lost). Pacheco's treatise on art, *El arte de la pintura*, published in 1649, contains important information concerning El Greco's working methods and ideas on art.

1614 El Greco dies on 7 April. Two Greek compatriots are witnesses at his deathbed; Luis de Castilla serves as his executor.

The artist is initially buried in Santo Domingo el Antiguo convent, where a funeral chapel with separate altar and altar painting (*Adoration of the Shepherds*) had been agreed upon in 1612.

When Luis de Castilla, the convent's patron, dies in 1618, disputes arise with the nuns over the price. This prompts the artist's son to remove his remains in 1619 to San Torcuato. When this church is demolished, El Greco's mortal remains vanish along with it. Jorge Manuel prepares an inventory of his father's possessions. It includes 143 largely finished pictures (including three versions of the *Laocoön*); 15 plaster models and 30 in clay and wax; 27 books in Greek (philosophy and poetry, the Old and New Testament, writings of the church fathers and the promulgations of the Council of Trent); 67 books in Italian, 17 in Spanish and 19 on architecture; 150 drawings; 30 plans (probably for altars) and 200 prints. His son's family continues to reside in El Greco's house.

1621 On the occasion of Jorge Manuel's second marriage, a further inventory of El Greco's estate is prepared.

1631 Jorge Manuel Theotokopoulos dies on 29 March. His only son, Gabriel Morales, had entered an Augustinian monastery in 1622.

1641 The renowned speaker and poet Fray Hortensio Félix Paravicino y Arteaga, whom El Greco portrayed, praises El Greco's art in several sonnets in his *Obras postumas, divinas y humanas*.

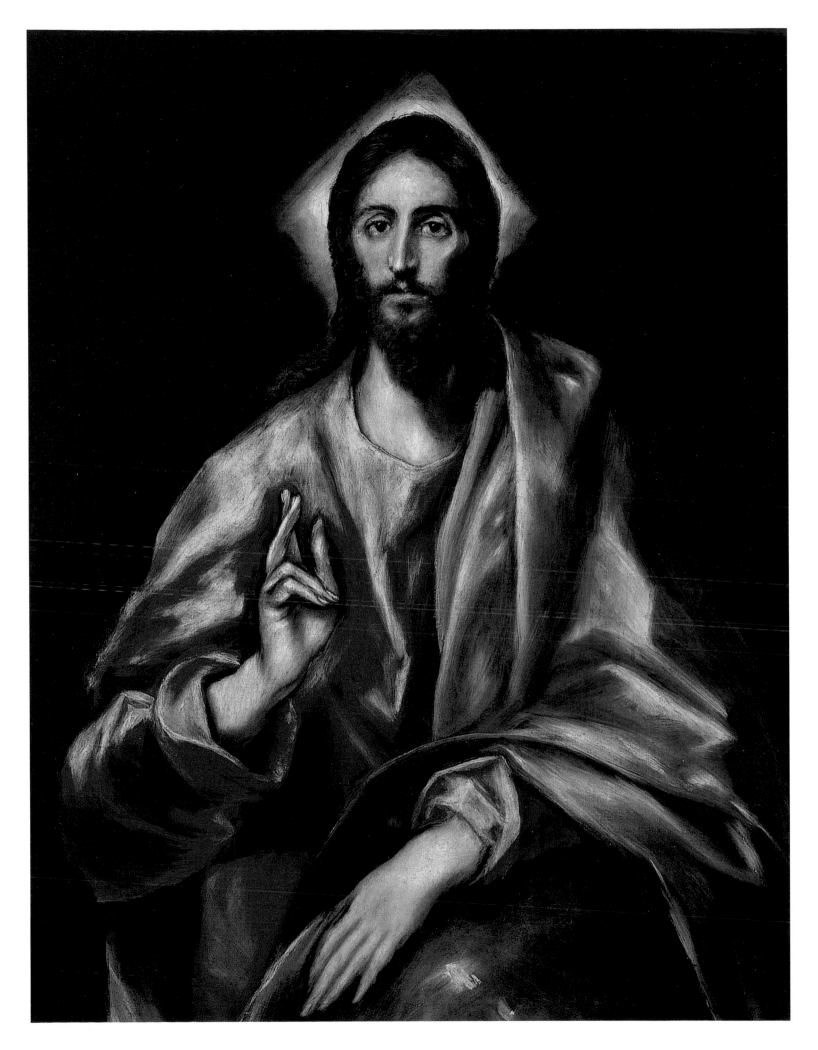

Bibliography

José Álvarez Lopera, *De Cean a Cossío: La fortuna crítica del Greco en el siglo XIX*, Madrid 1987

José Álvarez Lopera (ed.), *El Greco. Identity and Transformation: Crete. Italy. Spain*, exhibition catalogue, Museo Thyssen-Bornemisza, Madrid 1999

Xavier Barral i Altet (ed.), *Die Geschichte der spanischen Kunst*, Cologne 1997 (1996)

Bartolomé Bennassar and Bernard Vincent, *Spanien 16. und 17. Jahrhundert*, Stuttgart 1999

Barbara Borngässer (ed.), *Spanien: Kunst. Landschaft. Architektur*, Cologne 2001

Fernand Braudel, *Das Mittelmeer und die mediterrane Welt in der Epoche Philipps II.*, 3 vols., Frankfurt a. M. 1994 (1st edition 1949)

Jonathan Brown, *The Golden Age of Painting in Spain*, London 1990

Jonathan Brown et al. (eds.), *El Greco und Toledo*, Berlin 1983 (1982)

Manuel B. Cossío, *El Greco*, 3 vols., Madrid 1908

David Davies (ed.), *El Greco*, exhibition catalogue, The National Gallery, London 2003

El Greco. Su revalorización por el Modernismo catalán, exhibition catalogue, MNAC, Barcelona 1996

J.H. Elliott (ed.), *Die spanische Welt: Geschichte. Kultur. Gesellschaft*, Freiburg/Basle/Vienna 1991

Nicos Hadjinicolaou (ed.), *El Greco of Crete. Proceedings of the International Symposium Held on the Occasion of the 450th Anniversary of the Artist's Birth*, Municipality of Iraklion 1995

Sylvaine Hänsel and Henrik Karge (eds.), *Spanische Kunstgeschichte. Eine Einführung*, 2 vols., Berlin 1992

Silke Immenga, *Picasso und Spanien. Kulturelle Identität als Strategie*, Frankfurt a.M. 2000

Henrik Karge (ed.), *Vision oder Wirklichkeit. Die spanische Malerei der Neuzeit*, Munich 1991

Robert S. Lubar, Narrating the Nation: Picasso and the Myth of El Greco, in: Jonathan Brown (ed.), *Picasso and the Spanish Tradition*, New Haven and London 1996, pp. 27–60

Fernando Marías, *El Greco. Biografía de un pintor extravagante*, Madrid 1997

August L. Mayer, *El Greco*, Berlin 1931

August L. Mayer, *Geschichte der spanischen Malerei*, 2 vols., Leipzig 1913

Julius Meier-Graefe, *Spanische Reise*, Berlin 1910

John W. O'Malley, *Trent and All That*, Cambridge (Mass.)/London 2000

Francisco Pacheco, *El arte de la pintura* (Madrid 1649), edited by Bonaventura Bassegoda y Huegas, Madrid 1990

Antonio Palomino de Castro y Velasco, *El museo pictórico y escala óptica*, 2 vols., Madrid 1715–24

Heinz Schilling, *Die neue Zeit. Vom Christenheitseuropa zum Europa der Staaten 1250 bis 1750*, Berlin 1999

Michael Scholz-Hänsel, *El Greco. Der Großinquisitor*, Frankfurt a.M. 1991

Wilfried Seipel (ed.), *El Greco*, exhibition catalogue Kunsthistorisches Museum Wien, Milan 2001

Birgit Thiemann, Ignacio Zuloaga – Ein Maler als Vermittler im interkulturellen Austausch, in: Gisela Noehles-Doerk (ed.), *Kunst in Spanien im Blick des Fremden*, Frankfurt a.M. 1996, pp. 229–244

Martin Warnke, Julius Meier-Graefes "Spanische Reise" – ein kunstkritischer Paradigmenwechsel, in: Gisela Noehles-Doerk (ed.), ibid., pp. 221–228

Werner Weisbach, *Barockkunst und Gegenreformation*, Berlin 1921

Harold E. Wethey, *El Greco and his School*, 2 vols., Princeton 1962

Photo Credits